Witches *of* PENNSYLVANIA

D1114092

Witches of PENNSYLVANIA

OCCULT HISTORY & LORE

Thomas White

THE
History
PRESS

Published by The History Press
Charleston, SC 29403
www.historypress.net

Copyright © 2013 by Thomas White
All rights reserved

Front cover: Home of Nelson Rehmeyer (Hex Murder House). *Courtesy of the Stewartstown Historical Society.*
Back cover: Providence Meeting House. *Courtesy of Tony Lavorgne.*

First published 2013

Manufactured in the United States

ISBN 978.1.62619.132.7

Library of Congress CIP data applied for.

For my students

Contents

Acknowledgements

Preparing this book on the history and legends of witchcraft in Pennsylvania required the help and support of many people. I want to thank my wife, Justina, and my children, Tommy and Marisa, for allowing me the time to complete this project and for their support. For their continued encouragement, I also want to thank my brother, Ed, and my father, Tom. My mother, Jean, who passed away almost two years ago, encouraged my intellectual curiosity at a young age and will always influence any project that I work on. Paul Demilio, Zaina Boulos, Michelle Bertoni, Kelsy Traeger, Gerard O'Neil and Elizabeth Williams all spent time proofreading and editing for me, and their input and suggestions were greatly appreciated. Numerous librarians, archivists and historians helped me to find information and photographs, including Doug Winemiller at the Stewartstown Historical Society, Joel Alderfer at the Mennonite Heritage Center and Anna Marry Mooney, Dwight Copper and Andrew Henley of the Lawrence County Historical Society. J. Ross McGinnis, foremost expert on the York Hex Murder, graciously took the time to discuss his research with me and provide photographs. One of my students, Rachael Gerstein, shared her memories of a witch legend that she experienced growing up in Luzerne County. Her willingness to recount the story was appreciated, as was the tale of a mysterious witchcraft-related metal plate that was shared by Elizabeth Ringler and her father, Frank Bittner. I also want to thank writer and researcher Stephanie Hoover, who runs the interesting site Hauntingly Pennsylvania and who provided me with information on a Dauphin County

Acknowledgements

witchcraft incident. Many other people helped in a variety of ways while I worked on this project. They include Rebecca Lostetter, Michael Hassett, Bobbie Jo and Dave Leppo, Sean Coxen, Emily Jack, Art Louderback, Emily Kustanbauter, Dr. Joshua Forrest, Kelly Bennett, Maria Yalch, Stephan Bosnyak, Tony Lavorgne, Kurt Wilson, Ken Whiteleather, Brian McKee, Dan Simkins, Brett Cobbey, Will and Missy Goodboy, Brian Hallam, Vince Grubb and the students of my spring 2013 Shaping of the Modern World class and my Global Influence of Myth class. I would also like to thank Hannah Cassilly and the rest of the staff of The History Press for giving me the opportunity to write another book with them.

10

Witchcraft, Folk Healing and Hex in the Keystone State

There are few topics in history that are as widely popular as witches and witchcraft. The image of the witch has so permeated the Western imagination that almost anyone can provide at least a vague definition or description of one. Though European witchcraft is often the focus of professional historians, American culture is littered with accounts and images of witches and associated supernatural phenomena. From the well-known and extensively studied Salem Witch Trials to the Wicked Witch of the West and other stereotyped witches from literature and popular culture, it is clear that witchcraft has left its mark on the American psyche.

For many modern Americans, the study of historical witchcraft begins and ends with the Salem Witch Trials. The trials are often viewed as an anomaly by the armchair historian: an old and backward tradition carried over from Europe that was eradicated by the march of American progress and freedom. Yet this view is both historically inaccurate and deeply flawed. The belief in witchcraft existed throughout North America, and encounters with "real" witches were surprisingly common. Even today, though not as widespread, the belief in witches continues in a variety of forms.

Here in Pennsylvania, the state founded by William Penn and his Quaker associates, a multitude of accounts of witches and witchcraft exist. One reason for this is indirectly tied to the Quaker's general tolerance for other religious beliefs and peoples. The relative freedom of religion attracted numerous German immigrants who were members of both traditional and obscure religious sects. With them, those immigrants brought a strong

tradition of belief in witchcraft and the supernatural. Other settlers who came in later years also brought their own rich traditions of folk belief to the state. Luckily, Pennsylvania has a long record of preserving its folklore and history and many of these accounts of witchcraft have survived. Though such accounts are not always as thoroughly documented as scholars might prefer, they at least give us a window in which to view the occult world of our predecessors.

Witchcraft in Pennsylvania exists as part of the larger system of magical-religious folk healing and supernatural belief brought by the colonizers and immigrants. Throughout history, there have always been individuals in communities that were thought to be gifted or adept at what we would consider folk magic. Folk magic was the type of magic practiced by the common people, not the "high magic" of the educated sorcerers and necromancers of medieval and renaissance Europe. The practice of magical folk healing was laden with religious, primarily Christian, overtones but still contained vestiges of pre-Christian rituals. It could also contain elements of herbalism and traditional remedies. For the practitioners of this type of magic, there was no sharp distinction between religion, magic and science when it came to their work. The skilled individuals provided services to their community in the form of physical and mental healing; fortunetelling; locating lost people, animals and objects; protection; and removal of curses. In the English tradition, those practitioners were known as cunning folk. The Pennsylvania German tradition labeled them *brauchers*, powwowers or sometimes hex doctors. Other cultures provided them with different names, but they all performed similar functions in their social environment, and even though they dealt with what we might call occult forces, they were accepted as part of the social order.

At the far end of this magical-religious spectrum was the witch. The witch was skilled in the aforementioned practices but generally did not use them to help the community. Instead, the witch performed darker rituals to harm and harass his or her neighbors, utilizing magic to commit criminal acts. As historian Alison Games noted in *Witchcraft in Early North America*, "Witches, everyone agreed, were people who performed harmful acts and threatened the community order." By misusing their abilities, witches were relegated to the fringe of society.

But who were the witches? While some people today and in the past would consider the use of magic of any kind enough to warrant the label of witch, traditional witches certainly stood apart from the folk healers who invoked the name of God in their craft. Like in Europe, the source of a

witch's power was generally believed to have come from the Devil, whether or not a pact was made or his name was actually invoked. Theoretically, it is that line of good and evil that separates the witch from the folk healer. Yet many of the witches that we will encounter already seem to be on the fringe of society. Games pointed out in her study that in America, unlike Europe, a man was just as likely to be labeled a witch as a woman. They were often widows or widowers, hermits, persons of a different religious denomination, etc. Sometimes the line between folk healer and witch was difficult to establish. A person labeled a healer in one instance may be labeled a witch in a different set of circumstances. The blurring of the lines can make the study of witchcraft in Pennsylvania difficult.

The difficulties inherent in defending against charges of witchcraft have been noted by many historians. Perceived supernatural wrongs are identified with supernatural evidence. The very act of accusing someone of witchcraft could in itself be an act of revenge because of some previous disagreement. In Europe, witch trials often ended with an execution or a severe punishment of some sort. That was not the case in Pennsylvania. As we will see in the first section of this book, William Penn himself carefully judged Pennsylvania's only official witchcraft trial and set a precedent that prevented a situation similar to the one that occurred in Salem a few years later. If one wanted to stop or punish a witch here, they could not expect the legal system to do it for them. Instead, they had to rely on folk healers and hex doctors to engage in magical battle against the witch. Many of the stories that we discuss throughout this volume will detail such conflicts.

This book attempts to survey the role of witchcraft and its associated folk beliefs in Pennsylvania's magical landscape from the colonial days to the present. It by no means covers every account of witchcraft that has survived in the state, as they are too numerous for a volume of this size. What I have included are some of the key accounts of witchcraft and a sampling of lesser-known stories and incidents. As already mentioned, I will begin with William Penn's handling of the state's first witch trial. From there we move on to the Pennsylvania German traditions of powwow and hex and the role of the witch in their magical spectrum. I have included not only a brief overview of their practices but also a look at their magical books and uses for magic, both good and bad. The third part of the book will examine alleged cases of witchcraft and hex from various counties around the state, covering the years roughly from 1780 to 1920. After surveying the traditional accounts of witches, we turn to the shocking hex murders of the 1920s and 1930s and the impact that they had on people's ideas of witchcraft and traditional

powwowing practices. Finally, I will look at the role of the witch in modern folk belief in the form of urban legend.

For this survey, I have focused primarily on witchcraft-related beliefs in the European tradition. That being said, there are a few areas that I have intentionally chosen not to address in this volume. The first is the beliefs of Native Americans about witchcraft. Since their shamans and witches were generally viewed through the lens of the Europeans that encountered them, it is difficult to properly assess and explain their beliefs and what they really meant to those who practiced them. Such an undertaking would require a separate volume. Another extensive system of folk magic prevalent among the state's African American community was that of hoodoo or conjure. Unfortunately, that system is not as well documented here as it is in the American South, and most nineteenth- and early twentieth-century reports were filtered through the discriminatory opinions of contemporary newspaper writers. Like Native American beliefs about folk magic, I have decided not to address them here, but perhaps in a future publication. I will also not discuss the Wicca movement, which may be nominally identified with aspects of witchcraft but is a modern reinvention and not truly a part of the traditional system of folk belief.

Despite the persistent idea that witchcraft existed only in Pennsylvania Dutch Country, the belief in witches actually existed in every corner of the state, and much more recently than most would imagine. I hope that this volume will serve as an introduction to the history and the lore of the witch in Pennsylvania. Hopefully you will enjoy this journey through the occult history of the Keystone State.

Chapter 1

William Penn's Witches

Margaret Mattson stood before William Penn, the Provincial Council and a jury of prominent citizens of the colony of Pennsylvania. It was February 1684, and Mattson and her neighbor Yethro Hendrickson were accused of practicing witchcraft. They were the first to be officially charged with such an offense in the young English colony, and the outcome of their trial would set a precedent for the prosecution of witchcraft in the future. Both of the women were of Swedish descent and from families who were remnants of the defunct colony of New Sweden that had predated Penn's venture on the Delaware River. Mattson had pleaded "not guilty" to the charges against her at a prior arraignment, and Penn had assembled the council and a jury to hear the testimony of the women and their accusers. It seems that Hendrickson was not present at the trial as there is no official record of her speaking or giving testimony. An interpreter was present if needed, but it is not known how necessary he was or how much English Mattson could speak. It has been traditionally assumed that she spoke very little. The official record of the trial is sparse, so it has left many unanswered questions.

After convening the trial, several accusers were brought forth who testified that Mattson practiced the dark arts. A witness named Henry Drystreet claimed that he had been told twenty years before that Mattson was a witch and that she had bewitched the cattle of another farmer. Charles Ashcom asserted that Mattson's own daughter believed her to be a witch and that Mattson had threatened her in spectral form, standing at the foot of her bed with a knife. The old woman had also allegedly bewitched her cattle. A

woman named Annakey Coolin also believed that Mattson had used a spell on her cattle. Her husband had decided to boil the heart of a bewitched calf, presumably to draw out the witch. During the process, Mattson allegedly came to their door, disheveled and irate, demanding to know what they were doing. When they explained, she told them that they should have boiled the bones instead and muttered other "unseemly expressions."

Mattson denied all of the accusations, of course. She insisted she was not present for the boiling of the calf's heart and that she had no knowledge of the occurrence. She also questioned why her daughter was not present to testify if she believed her to be a witch. A common, but undocumented, legend about the trial tells that Penn himself questioned Mattson, asking if she ever rode through the air on a broomstick. Mattson allegedly did not understand the question and answered yes. Penn replied by asserting that there was no law against riding through the air on a broomstick.

When the testimony ceased, Penn met with the jury and gave them their charge concerning the case. Penn's directions were not recorded but can probably be guessed from the verdict. The jury deliberated briefly and returned with its decision. The jury found Mattson guilty of "having the common fame of being a witch, but not guilty in the manner and form she stands indicted." She was fined fifty pounds and released to the custody of her husband, Neels, to guarantee six months of good behavior. Despite being found innocent of witchcraft, Mattson has been known since as the Witch of Ridley Creek.

The unusual but wise verdict seems especially important in historical perspective, given that it occurred several years before the infamous Salem Witch Trials. While Penn and the jurors could not see into the future, they were certainly aware of the long history of witchcraft persecutions in Europe. To prevent such hysteria in the colony and to remain true to their pacifist Quaker beliefs, they could not set the precedent of convicting an accused witch, especially on such flimsy evidence. However, Penn and the jury were likely aware that the accusations against Mattson may have had more to do with personal vendettas than the black arts. Clearly, Mattson was not liked by many of her neighbors, and we will never know any more about her personality or interaction with others. Perhaps her neighbors were hostile to her because of her Swedish background or because they were jealous of her good land. To appease those who brought the charges against Mattson, the minor fine and "probation" would serve as a sufficient punishment and possible deterrent against future bad behavior without triggering more witchcraft accusations.

Even though the colony and future state of Pennsylvania would not prosecute witches, it could not prevent its citizens from believing in them. The Quakers had little tolerance for the prosecution of witches and, at the same time, had little use for magic and the occult. As the prominent historian David Hackett Fischer pointed out in *Albion's Seed*, the Quakers believed that evil in the world required no devil or magic but only the weakness and fallibility of men. However, as the colony grew and became successful, Pennsylvania's Quakers soon found themselves outnumbered in their own land. As people of different religious and ethnic backgrounds arrived in Penn's religiously liberated colony, they brought with them their own ideas about magic and witchcraft.

Evidence of the prevalence of such belief can be found throughout the 1700s in Philadelphia and its hinterlands. In 1701, a case of witch-related slander came to the city's court. A butcher named John Richards

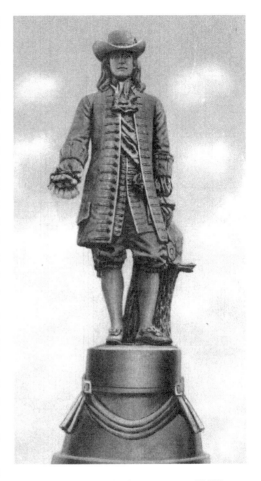

A postcard depicting the famous statue of William Penn that stands on top of city hall in Philadelphia. Penn's careful handling of the colony's first witch trial in 1684 prevented future prosecutions and the type of hysteria that would be seen in Salem several years later. *Author's collection.*

and his wife were being sued by Mr. and Mrs. Robert Guard for slander. The Richards accused the Guards of bewitching another woman who allegedly had pins taken out of her breast. The case was eventually dismissed as "trifling."

In Germantown, the practice of Pennsylvania German folk magic and folk healing was common. Well-known *brauchers* such as "Old Shrunk" Frailey offered their services to those who could pay, providing healing, removing curses and finding lost items and treasure. The practices of the German

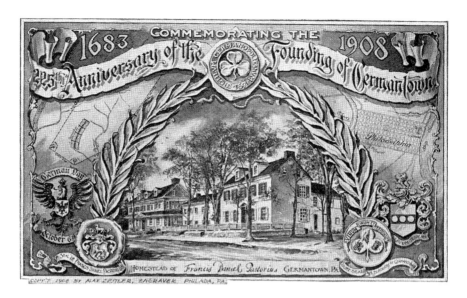

A postcard commemorating the founding of Germantown. Numerous German immigrants brought their traditions and culture to William Penn's colony. *Author's collection.*

immigrants would spread and heavily influence witchcraft lore throughout the state. We will examine their beliefs more closely in the next section of the book.

By May 1718, there were apparently enough rumors and minor accusations of witchcraft that the legislature included an English law regarding witchcraft from the time of King James II when it made modifications to the colony's legal system with the "Act for the Advancement of Justice." The "Act Against Conjuration, Witchcraft, and Dealing with Evil and Wicked Spirits" had entered English law in 1685 and was added word for word to the new colonial act. Its presence was meant to serve more as a deterrent than anything else, and the law was rarely used or enforced. The addition of the law failed, however, to have any substantial impact on the personal beliefs of Pennsylvania's residents. The very next year, an outbreak of witchcraft in Chester County led to the formation of a commission of judges from the county court specifically to deal with the occurrences. The commission was given authority to investigate all "witchcrafts, enchantments, sorcerers, and magic arts." We do not have any record of the commission's findings.

Further evidence of the continuing belief in witchcraft was uncovered during a 1976 archaeological excavation on Tinicum Island at Governor Printz State Park in Essington, not far from Philadelphia. Archaeologists discovered what is believed to be a "witch bottle," probably buried in the

1740s, on what was then the property of the Taylor family. Witch bottles have been found frequently in England and have traditionally been used as a charm to protect against or reverse the curse of a witch and possibly identify the individual responsible. They were used by those familiar with folk magic and might be prescribed by the local cunning folk. This particular bottle had six straight pins inside. Often witch bottles contained ritualized items such as these to represent the victim's pain or misfortune. They were mixed with urine or other bodily fluids of the victim and corked to trap the symptoms in the bottle and often reverse them on the witch. The witch might theoretically suffer until the bottle is uncorked. Similar techniques of sympathetic magic were used by the German immigrants as well. The presence of the bottle in Pennsylvania shows that at least some of the English settlers held onto the belief in witches.

Not everyone in early Pennsylvania took the belief in witchcraft quite so seriously. On October 22, 1730, Benjamin Franklin's *Pennsylvania Gazette* published a report of a witch trial just across the Delaware River near Burlington, New Jersey, titled "Witch Trial at Mount Holly." The article detailed the trial of a husband and wife accused of making sheep dance, hogs speak and generally causing terror among their neighbors. The accused witches agreed to be subject to two traditional tests to identify witches only if their accusers, another couple, agreed to submit to the same tests. They did, and over three hundred people from the town gathered to watch with anticipation. For the first test, each of the individuals had to step on a scale with the Bible on the other side. It was believed that a real witch would be lighter than the Bible. All four took their turn, and all outweighed the Good Book. The second test involved being tied up and thrown into water. If the person sank, they were not a witch, but if they floated, they were using supernatural forces to protect them. This time only the male accuser sank, and the other three remained floating on the water. The female accuser reportedly claimed that the witches were making her float, but some observers questioned whether the women's undergarments were trapping air and helping to keep them up. It was decided to pull them all from the water and wait until warmer weather, when they could be cast into the water naked. Though the story of the Mt. Holly trial spread quickly and was even reprinted in Britain, it turned out to be a hoax. It is now believed by many that it was Franklin himself who wrote the story to poke fun at superstition, and it seems to match the style of his satire.

Though the *Gazette*'s story was a hoax, it certainly seemed to be believable enough for many of its readers. The city of Philadelphia saw other

occasional, and very real, incidents involving accused witches as the century progresses. After refusing to prosecute an accused witch in 1749, authorities were forced to deal with a riot when angry citizens formed a mob to protest their inaction. In 1787, a tragic event occurred in the city's streets. A mob harassed and attacked an old woman who was believed to be a witch. She had been attacked on two previous occasions but had survived. This time the mob was relentless, shouting accusations and berating anyone who attempted to come to her aid. They began throwing stones, and the woman was killed in broad daylight.

Still, as the century progressed, the public presence of witchcraft in Philadelphia gradually declined. In 1754, Franklin tried to have the Witchcraft Act repealed by the colonial legislature, but his efforts were defeated. The act only disappeared in 1794 when the state was restructuring its legal system as part of the young United States. Witchcraft, in both belief and practice, was present behind closed doors, but it had become a subject of mockery for the urban elite and educated. The belief in witches still thrived in Pennsylvania, however, and is surprisingly well documented in Pennsylvania Dutch Country and in counties farther to the west. It is the folk traditions of the state's German population that dominate Pennsylvania's witchcraft traditions.

Chapter 2

Powwow and Hex

The Pennsylvania German Tradition

The most extensive and well-documented system of folk magic and healing in Pennsylvania is that belonging to the Pennsylvania German (or Dutch, as they are often called) immigrants and their descendants. It is also the system most associated with witchcraft as a result. Multitudes of German immigrants made the journey to Penn's Colony to take advantage of the economic opportunity and religious freedom that they could not find in Europe. At first they settled in large ethnic communities such as Germantown, but soon spread across the growing colony/state to take advantage of the fertile farmland and resources. The German settlement was particularly dense in the counties in the southeastern corner of the state around Philadelphia. The area eventually became known as Pennsylvania Dutch Country to legions of twentieth-century tourists. Though they became Americanized in many ways, the Germans held strongly to elements of their culture and blended New and Old World customs to form a distinct identity. Even their language became a unique Pennsylvania German dialect.

Though there were a great variety of religious denominations among these settlers, there was a common tradition of folk magic that was practiced across denominational lines, with the exception of the "Plain Dutch," such as the Amish, who rejected the practice. For large numbers of these Germans, the belief in folk magic was integrated with their Christian beliefs, as occult ideas were generally more acceptable in Germany than in England. At one end of the magical spectrum was the practice of *Brauche* or *Braucherei*, more commonly known as powwowing (not to be confused with the Native

American ceremonial practice of the same name.) Powwowers performed magical-religious folk healing and drew healing power from God. *Braucherei* is usually translated as "trying," or sometimes "using." At the other end of the spectrum was *Hexerei* or witchcraft. Practitioners of this form of black magic drew their power from the Devil or other ungodly sources. Since the perceived supernatural battle between good and evil was not going to be played out in Pennsylvania courts, the bewitched had to turn elsewhere for assistance. Powwowers and hex doctors filled the void for believers, and the culture of folk magic continued to flourish.

POWWOWERS, HEX DOCTORS AND WITCHES

Powwowers, and their equivalents in other ethnic groups and cultures, played an important role in the years before scientific medicine came into maturity. They offered relief from ailments and, more importantly, a degree of hope. The use of folk magic could provide a sense of control in a world that is often beyond control. Even after the professionalization of medicine, powwowers provided an explanation and a way to push back against misunderstood and unknown forces in the world. David Kriebel, in his masterful study *Powwowing Among the Pennsylvania Dutch*, succinctly identified the functions and services provided by powwowers. Generally, powwowers provided cures and relief from symptoms of illness, protection from evil and the removal of hexes and curses. They also located lost objects, animals and people; foretold the future; bound animals and people (such as rabid dogs and thieves); and provided good luck charms. To carry out these functions, powwowers used charms, amulets, incantations, prayers and ritualized objects. It was generally believed that anyone could powwow, but members of certain families were especially adept. These families passed the traditions down from generation to generation. Transmission of the practice usually alternated between sexes, unless there was not an heir of the opposite sex.

The opposite of the powwower was the witch, who utilized dark magic that was beyond the normal use of a folk healer. The witch harassed neighbors and committed criminal acts with supernatural power that was not of God. Sometimes these witches were called hex doctors. The term "hex doctor" can be confusing, however, because it can imply multiple things. Sometimes the term was applied to powwowers who were also knowledgeable in the ways of *Hexerei* and were skilled at battling witches and removing curses.

These hex doctors fell into a gray area between witch and powwower. Sometimes they would cast hexes for a price or out of revenge. It was not uncommon for someone to seek out one hex doctor to remove the curse of another. For many Pennsylvania Germans, and certainly for outsiders, the lines between powwower and witch were not as sharply drawn into our convenient categories. There are many who would label any use of folk magic as witchcraft, no matter the intention.

Since no one ever readily identified herself (or himself) as a witch, it is not always clear how one would learn the art of *Hexerei*. It was generally assumed, that even if the witch was not making a direct pact with the Devil, the witch was drawing her power from diabolical forces as a *teufelsdeiner*, or devil's servant. Richard Shaner identified several methods by which one could become a witch in the Pennsylvania German tradition. One particularly cruel method required the person wishing to become a witch to boil a black cat or a toad alive. The would-be witch would have to gather the unfortunate animal's bones and toss them into a stream or creek. One bone would supposedly float against the current. The bone would then serve as the witch's source of power. Another method involved the person drawing a circle on the ground made out of coal. She would then step into the circle while holding out her hand. The Devil would supposedly appear, taking her hand and marking it. From that point on, the person would have the power of a witch. A third possible way required the person to stand on a manure pile while swinging a hook around in the air. The person had to deny Christ and promise herself to the devil, and she would then be able to access the dark powers. There was also a book of spells and incantations that was usually associated with *Hexerei*, and that was *The Sixth and Seventh Books of Moses*. The book had a sinister reputation, which will be discussed shortly, and was rumored to be in the library of every witch and powerful hex doctor.

Witches could target their victims in many ways. Since *Hexerei* emerged in an agricultural society, many of a witch's attacks were directed at farm animals and crops. Witches were often blamed for cows not producing milk, the mysterious death of a seemingly healthy animal, sickness among herds and failure of crops. If a large hairball was found in the stomach of a dead animal, it was often labeled a "witch ball," and it might be attributed as the malevolent work of a local witch. When witches went after other people, they used a variety of torments. They were commonly suspected of causing illnesses, especially lingering conditions that caused a person to weaken and waste away over time. A witch could also assault his or her victim directly

SEAL OF THE SIXTH BOOK OF MOSES.

TREATISE SION.

The Seventh Book of Moses.

CHAPTER I.—THE SPIRIT APPEARS IN A
PILLAR OF FIRE BY NIGHT.

CHAP. II.—THE SPIRIT APPEARS IN A
PILLAR OF CLOUD BY DAY,

A page from *The Sixth and Seventh Books of Moses* depicting some of the reproduced seals and woodcuts that filled the volume. The book had a sinister reputation for those who believed in the power of folk magic and witchcraft because it contained instructions on how to conjure spirits. *Author's collection.*

with invisible attacks. This dark magic could cause seizures and fits, the sensation of being stabbed or poked with pins and the feeling of being choked or strangled. Witches were also believed to be able to cause a long run of bad luck for any individual on whom they turned their contempt. The witch could even appear in the form of an animal, such as a black cat or bat, to move about undetected and continue to harass his or her victim. Even though the previously mentioned attacks were the most common, almost any type of misfortune could be blamed on the curse of a witch.

THE PERFORMANCE OF PENNSYLVANIA GERMAN FOLK MAGIC

Powwowers, hex doctors and witches all used similar techniques and components in the process of healing or conjuring. Of course there were verbal components, including prayers, incantations and spoken charms. Most of these verbal elements were repeated three times. Powwowers frequently invoke God, Jesus and the Holy Spirit and sometimes other religious figures, depending on their denomination. Since they generally viewed their abilities as a gift from God and evil as the source of illness, this is not surprising. Witches, however, clearly would not reference God, though they usually would not reference the Devil either. The words, whether spoken loudly or softly, were frequently accompanied by hand gestures. Sometimes the powwowers would lay their hands on their patient; other times they would sweep their hands through the air over parts of their body. An example of a spoken charm is one of the many used to stop bleeding. The powwower breathes on the patient's wound three times and says the Lord's Prayer three times, stopping at the word Earth. After the third time, the bleeding will cease.

In addition to spoken words, the written word could serve to convey the power of magic. Written amulets and charms were common, and many Pennsylvania Germans carried them on their person. Amulets usually included a written version of a protective charm and perhaps verses from the Bible. The paper on which these amulets were written was often folded over into triangles and other shapes. If not carried personally, such amulets might be hung or posted in a house or barn. For example, the following charm against witchcraft and evil could be placed on the headboard of a bed or on the door of a stable or barn:

Trotter head, I forbid thee my house and premises; I forbid thee my horse and cow stable; I forbid thee my bedsted, that thou mayest not breathe upon me; breathe into some other house, until thou hast ascended every hill, until thou hast counted every fencepost, and until thou hast crossed every water. And thus dear day may come again into my house, in the name of God the Father, the Son, and the Holy Ghost. Amen.

The term "Trotter head," or *Trottenkopf,* is a variation of a word from the south of Germany that refers to malevolent spirits. Some versions of such a charm would include the property owner's name as well. Amulets could be made with material other than paper if necessary. To extinguish a fire without water, one needed to inscribe each side of a plate with a SATOR square as seen below:

$$S A T O R$$
$$A R E P O$$
$$T E N E T$$
$$O P E R A$$
$$R O T A S$$

The plate had to be thrown into the fire, and it would extinguish itself. Amulets like these were made for a variety of purposes to protect against both physical and supernatural harm. A SATOR square could also be written on a piece of paper and fed to a cow with its food to prevent it from being bewitched. (A SATOR square is a Latin palindrome thought to have mystical protective properties.)

Another key component of powwowing and hex is the use of ritualized objects. These objects seemed to be normal items, but they often acquired a special purpose. Sometimes one of these objects will serve as a surrogate for the afflicted or for the disease itself. Much of the German folk magic relies on the principles of contagion and transference. Basically the idea is that the evil or disease is contagious and can be transferred away from the afflicted person and into an object. The object can then be disposed of in some prescribed manner to prevent the further spread of the contagion. A classic example of this is the use of a potato to remove a wart. One would simply rub the potato on the wart, perhaps repeat an incantation and bury it in the ground. The wart would go away, and the evil that caused it was imprisoned in the earth. Traditionally, this type of magic where an object takes on the characteristics of a person or illness has been known as sympathetic magic,

though the term has fallen out of favor in recent years. Ritual objects and transference were often used to combat witchcraft, though they could be employed by witches as well. When a witch stole the milk of one of his or neighbor's cows, he did not have to be near the animal. Instead, he could hang a towel over the back of a kitchen chair, place a bucket underneath and "milk" the towel by pulling on the corners. The cow's milk would flow out of the towel and fill the bucket because the towel served as a ritual replacement for the animal itself. At the neighbor's farm, the residents would awake to find that their cow was "dry." In the next chapter, we will examine cases of witchcraft from around the state and see several cases where ritual objects were used to reverse the spells of witches.

GRIMOIRES AND MAGICAL BOOKS

Many powwowers and hex doctors relied on collections of charms, recipes and incantations that had been passed down through their families. These "recipe" books contained the collective knowledge that had been accumulated by a specific line of powwowers. By the mid-1800s, however, several published volumes entered common usage. These folk healers and folk magicians had always invoked and used the Bible in their magic, but they increasingly supplemented their knowledge with sources published by other powwowers. The most famous and widely read of these sources was compiled by a powwower named John George Hohman in 1819.

John George Hohman came to the United States through the port of Philadelphia from Hanover in 1802. He and his wife worked off their passage as indentured servants and eventually settled on a farm in Berks County. Unlike many of the other early powwowers, Hohman was a Roman Catholic and not a member of a Protestant denomination. As a side business, Hohman published broadsides and books about the occult and medicine targeted at Pennsylvania's German population. In time, he published the most widely known and read grimoire, or book of magic, in America.

Hohman's best compilation of spells, charms, prayers, remedies and medicine was completed in July 1819 and officially published in Reading in 1820. *Der lang verborgene Freund*, or *The Long Lost Friend* was the first lengthy assemblage of powwow practices to achieve wide circulation. The book has been in print in either German or English continuously since its original publication, sometimes under the expanded title *Pow Wows, or the Long Lost Friend*.

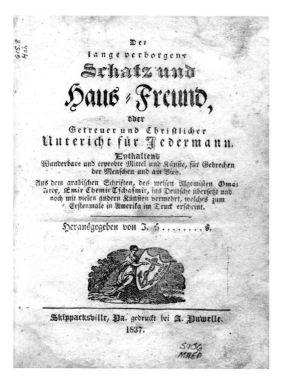

Der
lange verborgene
Schatz und
Haus - Freund,
oder
Getreuer und Christlicher
Unterricht für Jedermann.
Enthaltend
Wunderbare und erprobte Mittel und Künste, für Gebrechen
der Menschen und am Vieh.
Aus dem arabischen Schriften, des weisen Algemisten Omai
Zirey, Emir Chemir Tschasmir, ins Deutsche übersetzt und
noch mit vielen andern Künsten vermehrt, welches zum
Erstenmale in Amerika im Druck erscheint.

Herausgegeben von J. G........g.

Skippacksville, Pa. gedruckt bei A. Puwelle.
1837.

The title page of the 1837 German edition of the classic powwow book, *The Long Lost Friend* by John George Hohman. The slim volume of charms, prayers and recipes has never gone out of print since its first publication in 1820. *Courtesy of the Mennonite Heritage Center.*

In his introduction, Hohman claimed that both he and his wife were initially against publishing the volume, but he could not bring himself to withhold the cures from his fellow men who were suffering. It was, or was at least portrayed as, giving away the "trade secrets."

Aside from its broad collection of charms and recipes, the book became a talisman itself. In what was perhaps also a clever marketing ploy, those who carried the book were supposed to be protected from harm. In the front of each edition was an inscription that read: "Whoever carries this book with him, is safe from all enemies, visible and invisible; and whoever has this book with him cannot die without the holy corpse of Jesus Christ, nor drown in any water, nor burn up in any fire, nor can any unjust sentence be passed upon him. So help me. + + +"

The bulk of the book consisted of remedies and charms to cure common illnesses, fevers, burns, toothaches, epilepsy and other ailments. It also contained recommended recipes for beer and molasses and even had a charm for catching fish. A large portion of the charms in the book were meant to provide protection from physical harm, weapons, fire, witches and thieves. It provided instructions on how to bind thieves and animals to a specific location, heal livestock and cattle and even cure rabid animals. *The Long Lost Friend* quickly became the primary source of reference for outsiders attempting to understand the practice of powwow, and it found a place on almost every powwower's and hex doctor's shelf.

When it came to witchcraft, a far more dangerous volume was *The Sixth and Seventh Books of Moses*. Drawn from the tradition of European grimoires

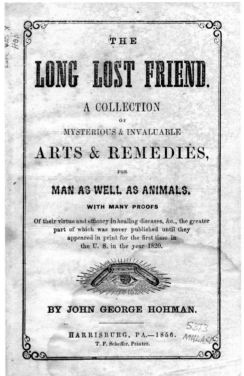

THE

LONG LOST FRIEND.

A COLLECTION

OF

MYSTERIOUS & INVALUABLE

ARTS & REMEDIES,

FOR

MAN AS WELL AS ANIMALS.

WITH MANY PROOFS

Of their virtue and efficacy in healing diseases, &c., the greater
part of which was never published until they
appeared in print for the first time in
the U. S. in the year 1820.

BY JOHN GEORGE HOHMAN.

HARRISBURG, PA.—1856.
T. F. Scheffer, Printer.

Right: The English language version of *The Long Lost Friend* from 1856. *Courtesy of the Mennonite Heritage Center.*

Below: Interior pages of the 1856 printing of *The Long Lost Friend* that provide instructions on creating charms and curing disease. *Courtesy of the Mennonite Heritage Center.*

14 ARTS AND REMEDIES.

To banish the Whooping Cough.

Cut three small bunches of hair from the crown of the head of a child that has never seen its father; sew this hair up in an unbleached rag and hang it around the neck of the child having the whooping cough. The thread with which the rag is sewed must also be unbleached.

Another remedy for the Whooping Cough, which has cured the majority of those who have applied it.

Thrust the child having the whooping cough three times through a black-berry bush, without speaking or saying anything. The bush, however, must be grown fast at the two ends, and the child must be thrust through three times in the same manner, that is to say, from the same side it was thrust through in the first place.

A good remedy to stop Bleeding.

This is the day on which the injury happened. Blood, thou must stop, until the Virgin Mary bring forth another son.— Repeat these words three times.

A good remedy for the Tooth-ache.

Stir the sore tooth with a needle until it draws blood; then take a thread and soak it with this blood. Then take vinegar and flour, mix them well so as to form a paste, and spread it on a rag, then wrap this rag around the root of an apple tree, and tie it very close with the above thread, after which the root must be well covered with ground.

How to walk and step securely in all places.

Jesus walketh with (*name*.) He is my head; I am his limb. Therefore walketh Jesus with (*name*.) † † †

A very good remedy for the Colic.

Take half a gill of good rye whiskey, and a pipe full of tobacco; put the whiskey in a bottle, then smoke the tobacco and blow the smoke into the bottle, shake it up well and drink it. This has cured the author of this book, and many others.

'ARTS AND REMEDIES. 15

Or take a white clay pipe which has turned blackish from smoking, pound it to a fine powder, and take it This will have the same effect.

To banish Convulsive Fevers.

Write the following letters on a piece of white paper, sew it in a piece of linen or muslin, and hang it around the neck until the fever leaves you:

Abaxa Catabax
Abaxa Catabax
Abaxa Cataba
Abaxa Catab
Abaxa Cata
Abaxa Cat
Abaxa Ca
Abaxa C
Abaxa
Abax
Aba
Ab

How to banish the Fever.

Write the following words upon a paper and wrap it up in knot-grass, (breiten Wegrich,) and then tie it upon the navel of the person who has the fever:

Potmat sineat,
Potmat sineat,
Potmat sineat.

A very good Plaster.

I doubt very much whether any physician in the United States can make a plaster equal to this. It heals the white swelling, and has cured the sore leg of a woman who for 18 years had used the prescriptions of doctors in vain.

Take two quarts of cider, one pound of bees-wax, one pound of sheep-tallow, and one pound of tobacco; boil the tobacco in the cider till the strength is out, and then strain it, and add the other articles to the liquid, stir it over a gentle fire till all is dissolved.

and ceremonial magic, *The Sixth and Seventh Books of Moses* are purported to have been authored by Moses himself and allegedly contain secret knowledge that was not passed on in the canonical books of the Bible. Described as two separate books, they are almost always published together in one volume. Though it draws on earlier traditions of European magic, the first printed edition only came to market in 1849 in Pennsylvania. The book had an evil reputation among the German population and those who were familiar with its lore. It was associated with hexing because the text provided instructions on how to conjure and control spirits and demons. Also included were other spells and incantations that provided benefits to the user. Supposedly a record of Moses's secret incantations, the book includes spells that will duplicate some of the Biblical plagues of Egypt, turn a staff into a serpent and other miraculous happenings. Included with the secret knowledge, most versions contain instructions on conjuring added by Dr. Faust, an essay on the magic of the Israelites and various explanations of cabalistic magic. Much of the volume is made up of reproduced seals that were allegedly copied directly from old woodcuts. Some copies have been printed, at least partially, with red ink. Some hand-copied additions were also rumored to be written in red ink or even blood. Writing on both the seals and in the text appears in several languages, including Hebrew, Greek,

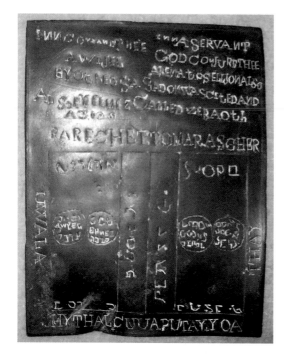

This metal plate was discovered by Frank Bittner in 1948 at a construction site near Keyser's Ridge in northern Maryland, close to the Pennsylvania border. It was located ten feet below the surface. The arcane writing on the plate is copied directly from a seal in *The Sixth and Seventh Books of Moses*, and it was intended to be buried ten feet underground. One who followed the instructions and buried the plate on his property would have his land yield "the treasures of the earth." *Courtesy of Elizabeth Ringler.*

English or German (depending on the publisher) and possibly some Egyptian Demotic, as identified by David Kriebel.

Though hex doctors frequently acquired the volume to enhance their reputations, merely owning the volume was believed to have some dangers.

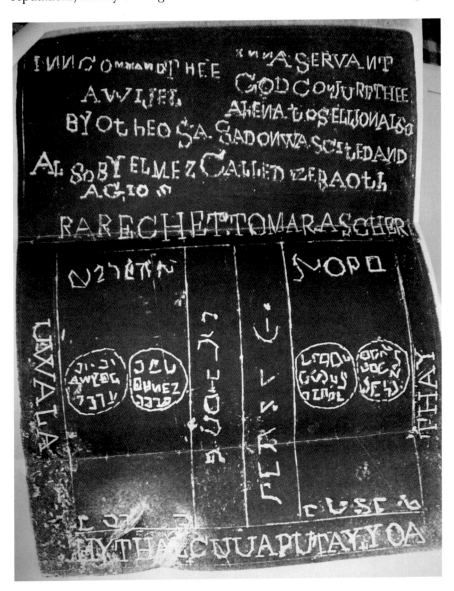

This paper copy of the metal plate discovered by Frank Bittner shows the writing more clearly. Grimoires of the hex doctors contained directions for creating talismans such as this. *Courtesy of Elizabeth Ringler.*

Some believed that physically possessing the book would lead one to commit oneself to the Devil. More commonly, it was believed that the real danger came when one began to read the volume. Anyone who began to explore its secrets was in danger of being "read fast." That meant that the reader would become obsessed with the book and continue to read it constantly, neglecting everything else in his life. It could also mean that the reader would become so obsessed with the evil power that the book provided that it would dominate his life. If one found himself read fast, the only way to escape the torment was to read the entire book in reverse, starting at the end and working toward the beginning. Doing this, or having a powwower read it to the victim in the same manner, would allow the person to be "read out" of its power.

Another grimoire sometimes used by both powwowers and hex doctors was the *Egyptian Secrets of Albertus Magnus*. Similar to *The Sixth and Seventh Books of Moses*, the *Egyptian Secrets* were a compilation of earlier European magical texts attributed to the authorship of Albertus Magnus. The volume contained spells and incantations that could be used for good as well as information on conjuring and black magic. The dual nature of the work makes it difficult to classify, and it was not as popular as the two previously mentioned volumes, even though it existed long before the others had entered print. It also never acquired quite the sinister reputation of *The Sixth and Seventh Books of Moses*.

HEX SIGNS

The meaning of the colorful and circular Pennsylvania German barn decorations, popularly known as hex signs, has long been a source of controversy. The signs, which became popular in the twentieth century, seem to have emerged from an earlier tradition of painting decorative stars on barns and other wooden artifacts. Popular opinion holds that the stars and the hex signs, which often contain other symbols, are a form of supernatural talisman or charm to protect the structure that they are on. The consensus among many academics is that they were purely decorative, and any supernatural purpose has recently been ascribed to them. A detailed discussion of this debate is beyond the scope of this book and has been covered extensively in other publications, but it may simply be that the symbols were ascribed supernatural significance by some people and not by others. They are still popular today and have spread well beyond their place of origin in Pennsylvania Dutch Country.

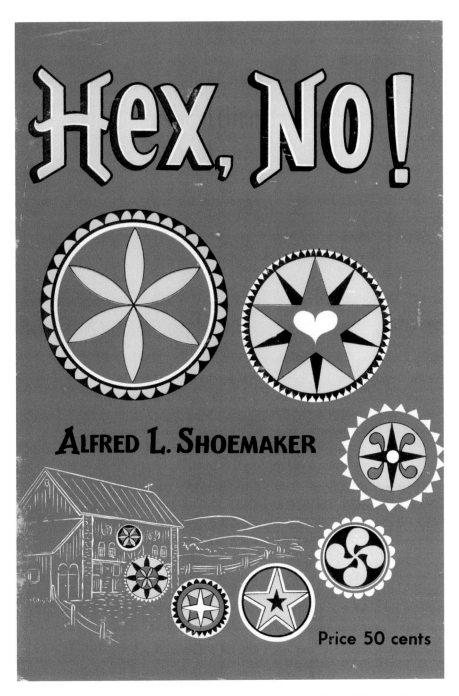

Hex, No!, written by folklorist Alfred Shoemaker in 1953, was the first published challenge to the idea that the popular Pennsylvania Dutch hex signs were authentic mystical symbols. *Author's collection.*

Regardless of the true nature of the symbols, believers in witchcraft had other methods to protect their barns and the animals inside. One way to stop a witch from entering was to draw or carve a five-pointed star in the doorframe where it could not be seen. Such stars were called *hexafoos* or the witch's foot. Various other charms, like the one mentioned previously, could be written on paper and hung or hidden in the barn for the same purpose. Another method of keeping a witch out required the mixing of cow and hog blood. The mixture had to be spread above every doorframe, and a witch would be unable to pass through to harm the animals inside. Other equally gory options included nailing a toad's foot above the door or the foot of a goose within a *hexafoo*.

Chapter 3

Accounts of Witchcraft from Around the State

1780–1920

N ow that we are familiar with some of the mechanics of Pennsylvania German folk magic, we can examine some specific accounts of its practice. A surprisingly large number of nineteenth- and early twentieth-century witch stories have survived in Pennsylvania. These accounts come from a variety of sources, but many common themes are present throughout the tales. Most fit or at least appear to fit within the Pennsylvania German tradition of folk magic. Some of the accounts were gathered by folklorists and historians in the early and mid-twentieth century. Those professionals provided more details and explored their subjects with greater depth. Others appeared in county histories from the late nineteenth and early twentieth centuries and in local newspapers. County histories tended to use the accounts of witchcraft to demonstrate the backward thinking of our ancestors and the progress that was being made in the local community and society as a whole. Newspaper accounts tended to be critical of any who believed in the supernatural power of witches, yet publishers did not hesitate to print the stories and any lurid details to sell papers. They were especially fond of stories that demonstrated the gullibility of witchcraft believers and portrayed the practitioners of folk magic as charlatans. Hostility toward believers in folk magic became increasingly apparent in the press from the 1890s onward, as did stereotypes of the "superstitious Dutch." The sampling of witchcraft accounts and legends included in this chapter demonstrates just how pervasive the belief system was in spite of the continued intellectual assault on its practitioners. This collection is by no means comprehensive, as there are literally hundreds of reports and stories that have survived in some form.

A "WITCH TRIAL" IN ALLEGHENY COUNTY

An unofficial witch trial was held at the western end of the state in Allegheny County at the beginning of the nineteenth century, just upriver from the city of Pittsburgh. Our only account of this "trial" was passed along by the judge at the center of the incident, B.F. Brewster. The judge had settled and built his home in Harmar Township in 1798 after purchasing Twelve Mile Island in the Allegheny River. He probably expected to have peace and quiet on his lonely island and almost certainly did not expect to conduct the pseudo-trial of an accused witch.

The tranquility of his home and estate were shattered one day in 1802 when an angry mob of local citizens dragged a frightened woman to the judge's doorstep. When the bewildered judge came to the door to address the crowd, they emphatically demanded that he try the unnamed woman for practicing witchcraft. Seeing that the mob was serious, and perhaps having a little too much faith in his fellow citizens' ability to reason, Brewster agreed to have a sham trial. The judge naturally assumed that the crowd would be unable to produce any real evidence that the woman was a practicing witch, so he would be able to find her not guilty and diffuse the issue. He began the "trial" immediately onsite.

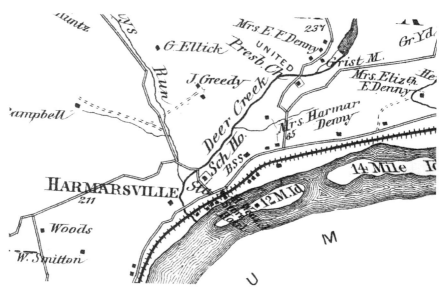

Twelve Mile Island in Allegheny County was the scene of an impromptu witch trial in 1802. The island is depicted here on a map from 1872. *Courtesy of the Library and Archives Division, Senator John Heinz Pittsburgh Regional History Center.*

Brewster was rapidly disappointed when many members of the crowd came forward with accounts of bewitchment that they believed constituted legitimate evidence. Those accounts were not recorded, but it is clear that the judge placed no merit in them. At some point during the testimony, members of the mob began to demand that the witch be executed. Realizing that events were taking a potentially dangerous turn, Brewster told the crowd that he needed a little time to consult his legal books before he could render a final decision. Reluctantly, the mob agreed to wait. The accused witch was taken inside and held in custody in the judge's home while he pretended to conduct his research.

Once Brewster and the woman were away from the crowd, he quickly arranged for her to secretly escape his house and sneak away. The judge's account does not explain the details of the escape. After stalling long enough for the woman to get clear of the mob, Brewster reemerged from his home to announce that the woman had gone. Since she was no longer present, he could not render a verdict. Members of the crowd became enraged, and some even threatened the judge's safety and his home. However, Brewster would not relent, and the mob eventually dispersed and returned to their homes.

Clinton County's Witches

Dr. Homer Rosenberger, former president of the Pennsylvania German Society, gathered several accounts of witches and their supernatural activities when he lived in Clinton County during the 1930s. Luckily, he published several of these reports originally in *The Clinton County Weekly* and later in *Keystone Folklore Quarterly*. His writings show that many of the residents of Clinton County held a strong belief in the supernatural.

The region around Farrandsville was apparently home to two practitioners of magic in the 1880s. One of these was a woman named Sal Kervine. In her eighties by that time, she lived alone outside of town in a log cabin located along a logging road. Many people in Farrandsville believed that the strange old woman practiced witchcraft, and they feared offending her because they did not want to be on the receiving end of her magic. Kervine would often turn her anger against the teamsters that pulled the logs down the road near her home. A clean and accessible spring was located very close to her house, and sometimes the teamsters would stop to draw water for

themselves and their horses. Kervine felt that the spring was hers alone, and she warned them not to stop there. After the men refused to listen to the old woman, she allegedly bewitched their wagons. When they would stop for water, the men could not get their wagons to move again. No matter how much their horses pulled, it seemed as if an invisible force held the wagons in place. The teamsters would be delayed for long periods of time before they could get moving again, making them late for their deliveries. The strange occurrence happened so many times that the teamsters avoided Kervine's spring and moved past her house as quickly as possible.

A teamster named Tom Stewart, who delivered three loads of logs every day, regularly passed Kervine's home and used the spring. One day when he stopped, he got into an argument with Kervine over some trivial matter. After that, the old woman glared at him every time he went by. About two months later, Stewart decided to stop at the spring for a drink after his second trip down the road. He was running about half of an hour late already, but it was such a hot day that he and his horses needed a drink. After quenching his thirst, Stewart boarded the wagon and signaled his horses to start moving. The animals began to pull, but the wagon would not budge. Stewart then whipped the horses lightly, and the whole team pulled as hard as they could. Still, the wagon would not move. The teamster then realized what was happening. His wagon was being held in place by the witch's spell. He grabbed his axe, jumped off the wagon, and in one swing broke one of the spokes on the first wheel. Quickly he climbed back on board and ordered the horses forward. This time they pulled the wagon as they always had, and Stewart was on his way.

Curiosity got the better of Stewart, so the next day he looked for Kervine as he passed her home. Not seeing her outside, he decided to peek into her house. What he saw confirmed his belief about the incident the previous day: Kervine's arm was broken. Tom Stewart was never again bothered by the witch.

About five miles away from Sal Kervine lived a hex doctor named John Applegate. In his sixties, Applegate was a farmer and lumberman and was known locally for his magical skills. Unlike Kervine, most people seemed to get along with Applegate, though they feared and respected his abilities. Rosenberger recorded one story of Applegate using folk magic in a helpful manner.

Over the course of one summer, Applegate and two of his neighbors, farmers named Brown and Wells, let their twenty-four cattle wander out into open pasture to feed. This was a common practice since good pastures

were hard to come by in the mountains. Though it took some work to round up the animals in the late summer, rarely did the farmers ever lose one. That particular summer, however, the three farmers had a problem. When it came time to bring in the cattle, not a single one could be found. For three days and nights, the trio of farmers searched, and they could find no signs or recent tracks of the animals. Never did they even hear the distant sound of a cowbell. At the end of the third day, they were exhausted, and Applegate insisted that the other two men stay at his house for the night. Brown decided to go home, but Wells reluctantly stayed at the hex doctor's home. Applegate promised him that he would make sure that the cattle were home by morning. Applegate provided Wells with dinner and showed him to a guest room for the night.

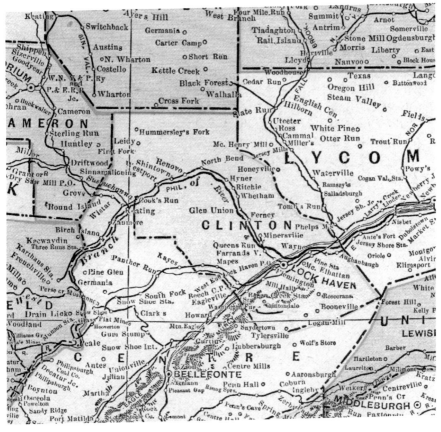

Numerous tales of witches, hex doctors and powwowers were recorded in Clinton County in central Pennsylvania. This map shows the county in 1890. *Author's collection.*

Wells awoke very early the next morning just as the sun was rising. The farmer was casually looking out the window when he noticed that Applegate had walked out of the house with a large Bible and a pair of scissors. Applegate stood at the corner of the house and seemed to read a chapter from the Bible. He then opened up the scissors so that they formed an "X" shape, placed them on the open page and then closed the book. Wells reported that Applegate proceeded to place the Bible on a log and then pace around the yard, scanning the horizon. About fifteen minutes later, Applegate froze in place and became tense, as if something was about to happen. Just then Wells began to hear the sound of cowbells in the distance. They became louder and louder until the cattle—all twenty-four of them—came charging into the clearing. Though Wells was glad to have his animals back, he believed that Applegate had actually summoned an evil spirit to drive the cattle home. He vowed never to sleep at Applegate's house again.

Another Clinton County witch tale emerged from the small logging community of Pine Station. Like many of the other alleged witches, Susan Gahagan lived alone in a small house. Though most of the town's residents believed her to be respectable, a few believed that she was skilled in the dark arts. One family in particular, the Bensons, felt that they were the victims of her hexes.

Gahagan had a habit that her neighbors found bothersome and annoying. She borrowed things almost daily from the people that lived around her. Coffee, flour, sugar, utensils—anything that she needed she tried to acquire from her neighbors. Those who believed in her supernatural abilities always gave the woman what she asked for because they did not wish to invoke her wrath. The Bensons could not always afford to be so generous, and during one summer in the late 1860s, Mrs. Benson turned her away almost every time that she came around.

Near the end of that summer, strange things began to happen to a horse belonging to eighteen-year-old Sarah Benson. Though Sarah's horse was securely tied in a stall, each morning for about a week she would find the horse "all sweated up" as if it were recently ridden hard. Not only did the horse appear to have had some nocturnal exercise, but its tail was also braided. Sarah made sure the tail was not braided when she went to bed, but in the morning the braid was present again. A family friend known as Grandmother Stang recognized the work of a witch. In fact, such occurrences were commonly reported as signs of witchcraft in the state. Witches were thought to torment the poor animals by riding them all night. Stang had been raised in York County and was familiar with the traditions of powwow

and hex. She identified Gahagan as the source of the problem, claiming that the woman had cursed Sarah. No remedy was prescribed however, and the curse seemed to fade by the end of the summer.

By the early 1870s, Sarah had married Sam Hogan and was running a successful hotel in Pine Station. The couple had a daughter named Betsy. Grandmother Stang had come to live at the hotel by that point and was raising her two grandchildren, Henry and Kittie, at the establishment. The three children were friends and played together frequently. Around the time that Betsy was nine years old, the children experienced something strange at the hotel. One day when the three children were in the kitchen with Sarah, they heard a loud noise from the basement. The youngsters ran down to investigate only to find that a cask holding nearly seventy pounds of lard had been knocked over. Nothing else in the room was disturbed, and no one was in the basement. The cask had been kept on a solid table, and neither the children nor Sarah could figure out how it was toppled. When the commotion over the incident reached the ears of Grandmother Stang, the old woman went to examine the scene herself. When she was finished looking around, she announced that the strange happening was the result of another curse leveled by the witch Susan Gahagan. Stang then suggested that Sarah stick a red-hot iron through the cask to break the curse and burn Gahagan's arm in the process. The witch's powers would be lost until Sarah decided to lend her something when she came around begging.

Sarah did as suggested, and sure enough, Gahagan knocked on the door the next day asking for sugar. The witch's arm was wrapped in bandages. Sarah remembered what Grandmother Stang had told her and refused to lend any sugar. Gahagan continued to beg and asked for some coffee. Sarah again refused, and Gahagan went away empty-handed. For days after, Gahagan returned, asking for the same things and looking more pathetic each time. Eventually Sarah felt pity for her and lent her some flour. The woman went away, and there were no incidents for the next six months.

Eventually, young Betsy became ill. She seemed to be wasting away and, after months of treatment, showed no signs of improvement. Grandmother Stang once again identified Susan Gahagan as the source of the ailment, suggesting that she was out for revenge again. Sarah trusted Stang's judgment and prepared to do whatever was prescribed to break the spell. Susan, the witch, was known to drink tea every day around noon, the same time that tea was regularly given to Betsy. Stang ordered Sarah to take the tea meant for Betsy, seal it in a bottle and place the bottle in the linen chest. The keyhole on the chest was also plugged, cutting off the only potential

opening. The ritual was meant to leave the witch powerless. It turned out to have additional effects.

The following afternoon Susan Gahagan came to the door and confessed to being a witch and to placing the spell on Betsy. She was in severe pain because she was unable to empty from her stomach the tea that she had consumed over the course of the previous day. Doubled over, she begged Sarah to unplug the keyhole on the linen chest, promising over and over again that she would not curse anyone again. Eventually Sarah had pity on the old woman and cleared the keyhole. As soon as she did this, the witch reportedly vomited almost three pints worth of tea. Gahagan never used her magic against Sarah's family again. Betsy recovered from her ailment quickly after the incident and remained healthy.

The final witch story the Rosenberger collected is lacking in specific details and occurred in the Sugar Valley area. In his retelling, Rosenberger assigned fictitious names to the characters because all but one had been forgotten over time. Even the exact location could not be narrowed any further than a mill in Sugar Valley. Though I will not use Rosenberger's false names, I also will not attempt to guess and identify the characters in the story since it is extremely unlikely that their identities could be confirmed.

The story begins with a gristmill in Sugar Valley in 1872. The mill had the reputation of being haunted, and as a result, the mill owner had difficulty keeping an employee to perform the lonely work on the night shift. After a few nights at the mill, every worker he hired had some type of supernatural experience and refused to come back. There was a shrewd and perceptive forty-year-old man who lived in the community who had heard the stories of the mill and was interested to see what was really going on. The man happened to be between jobs, so he approached the mill owner about the position. The mill owner hesitantly hired the man, hoping that he would stick around longer than his previous employees.

That night, the curious man began his work in the mill. He worked hard without taking breaks but kept a close eye on his surroundings for anything unusual. During that first night, only one strange thing happened. A black cat seemed to appear out of nowhere, walked through the mill and then vanished. On his second night of work, the man went about adjusting the mill stones, setting the hoppers, and a variety of other tasks. After a few hours, he decided to take a short break and went in to the small office on the first floor. Once inside, he reclined on the couch and shut his eyes, pretending to sleep. Before lying down he had placed a small hatchet next to him on the couch where it could not be easily seen. Suspecting that he might

have another supernatural encounter, he patiently waited. After only a few minutes, he heard the barely audible sound of the black cat's feet on the wooden floor. The mysterious animal entered the office and approached the couch. In a surreal motion, the cat stood up on its hind legs and appeared to grow in size. It raised its left paw above the man's face preparing to strike when the man sprung up with his hatchet and hacked three toes off the cat's left paw. The cat vanished immediately and did not reappear that night.

When his shift was over in the morning, the man walked directly to the mill owner's house. About halfway there, he encountered the owner heading toward the mill. The man told him that he wanted to speak to his wife. The mill owner told him that he could not because she was sick. The man continued toward the mill owner's house anyway. When he arrived, the owner's daughter also tried to turn him away, but he refused to be deterred. Walking right past the daughter, the man entered the wife's bedroom. When his eyes fell upon her he immediately noticed that her left hand and fingers were bandaged. He accused the wife of being a witch and the source of the problems at the mill. The wife begged him not to tell anyone, not even her husband. From that point on, nothing strange happened in the mill again.

HEXENKOPF AND WITCHES IN NORTHAMPTON COUNTY

In Pennsylvania German folk culture, certain locations and geographical features were believed to have been more supernaturally active than others. Back in Germany, specific mountains, such as Brocken Mountain, were thought to be the meeting places of witches and the home of supernatural evil. When the Germans settled in America, they brought with them their traditions of such cursed places. Maps of Pennsylvania Dutch Country reveal a landscape dotted with unusual names, some with magical connotations. The most well known and well documented of these places is located in Williams Township in Northampton County. Hexenkopf Rock, at the top of Hexenkopf Hill, is located south of Easton and has been a center of legend and mystery for over two centuries.

The name Hexenkopf translates from German as "the witch's head." Since the late 1700s, stories of witches, ghosts and supernatural occurrences have proliferated around the hill. One popular legend involved the Indians who once lived around the site. It was said that they would use magic to

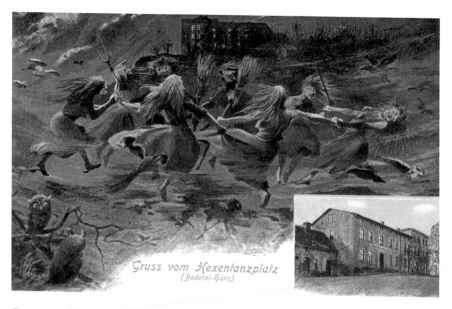

Gruss vom Hexentanzplatz
(Bodetal-Harz)

German traditions of witches' mountains traveled to Pennsylvania with the German immigrants. *Hexentanzplatz*, or the "witches' dance floor," was a plateau in the Harz Mountains in Germany. Witches were said to gather there on Walpurgis Night and dance in circles, as depicted in this postcard from the 1920s. Similar stories were told of Hexenkopf Hill in Northampton County and Witches' Hill in Berks County. *Author's collection.*

drive the evil spirits out of their sick and the possessed and imprison them in Hexenkopf Rock or the hill itself. Powwowers and hex doctors were also alleged to have performed similar rituals of transference at the same location. Due to the large number of spirits imprisoned in the rock, the hill reportedly gave off an eerie glow at night. Another common legend about Hexenkopf was that it was the meeting place of a coven (or group) of witches, especially on Walpurgis Night (April 30). If you saw the hill glowing under a full moon, you knew that the witches had assembled there for their dark ceremonies. The witches sang, danced and participated in the witches' sabbath, sometimes with the Devil himself. In fact, Hexenkopf Rock vaguely resembles a stereotypical witch's face when viewed in profile. In more recent years, the hill was allegedly the gathering place of a satanic cult. These stories and other dark tales about the hill have led to the use of another nickname for Hexenkopf: Misery Mountain. But is there any truth behind the numerous legends surrounding the rock?

Luckily, historian Ned D. Heindel produced a thorough and detailed history of this unique site entitled *Hexenkopf: History, Healing, and Hexerei*. The interesting volume not only relates the historical truths about Hexenkopf

but examines its legends as well. Heindel found no definitive evidence that the hill was used by American Indians for magical purposes, though it is believed they may have inhabited it in the past. He did discover that the name of the hill and its reputation for magic and witchcraft did not appear in the historical record before the arrival of Johann Peter Seiler (later Americanized to Saylor.) Saylor moved to the land around Hexenkopf (what is today Saylor's Lane in Raubsville) by the 1770s.

Saylor had originally emigrated from Germany in 1738 and settled in New Jersey before coming to Pennsylvania. He quickly established a reputation for himself as a healer by employing the methods of the powwowers. One legend insists that it was Saylor's work that led to the use of the term powwow as applied to *braucherei*. After successfully treating several Indians, the natives began to use the term when describing their interaction with him. It apparently caught on and came to be used to describe the work of all the folk healers of German descent. Though the story cannot be confirmed, Heindel asserts that Saylor was definitely one of the first *brauchers* to be described with the term. In addition to having a successful career, Saylor established a long line of powwowers who inhabited the area near Hexenkopf well into the twentieth century. It is perhaps the most well documented line of powwowers in the state, and their continuous association with the hill would cement its reputation in local lore.

Before his death, Johann trained his youngest son, Peter, in the art of powwow and hex. It was Peter who would take over his father's medical practice in Williams Township. Born in 1770, Peter lived ninety-one years and became the most well-known powwower of the line. It was Peter who was known to practice the art of "transference," which is the act of "draining out" the disease or curse from a living person and transferring it into an inanimate object. Hexenkopf was not far from Peter's home, and he was known to frequently transfer his patients' illnesses into the rock. Peter, like other powwowers, believed that disease was caused by an evil of some sort, so imprisoning in Hexenkopf prevented it from causing further harm. It is most likely that Peter's use of Hexenkopf for this purpose was the inspiration for many of the legends that grew up around the hill.

Over Peter's long career, numerous anecdotes about his use of magic were passed around in the community. The stories range from his allegedly winning a shooting contest by using a charm to trapping a thief within a magic circle. Though he was respected for his abilities, Peter was never considered to be a witch. In the traditional fashion, Peter trained his son, Peter Jr., and possibly his nephew Jacob, to be powwowers. Peter Jr. continued to practice until his

death in 1868. Peter Jr. did not have a direct heir, so his knowledge was passed on to another relative in Williams Township named John Henry Wilhelm. At one point, Wilhelm was accused not of witchcraft but of practicing medicine without a license. He apparently received enough support in the township that the accusation had little impact on his practice. After John died in 1886, his son Eugene became the next powwower. He added new elements to the traditions that he inherited, including an increased use of herbal remedies and traditional medications and "magnetic treatments." When Eugene died suddenly in 1905, his son Arthur followed in his footsteps and adapted to the increased pressure for professionalization that had developed by that time. Arthur went to school for and received a traditional medical doctorate but also continued to practice powwow and use homeopathic remedies. His

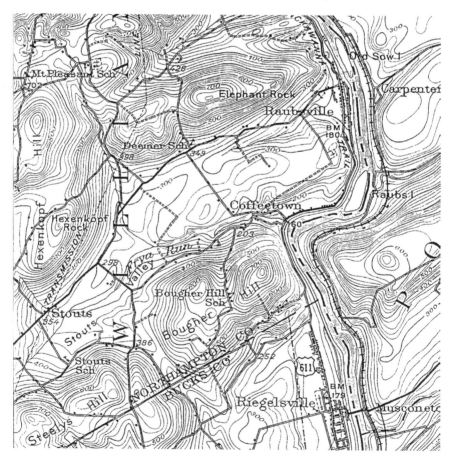

Hexenkopf Hill and Hexenkopf Rock are shown on this topographical map from the 1940s. *Courtesy of the U.S. Geological Survey.*

success and reputation in Raubsville attracted clients from other counties in the state. Arthur's death in 1950 brought an end to the long line of *brauchers* that had inadvertently helped to create the legend of Hexenkopf.

In addition to tracing the line of powwowers associated with Hexenkopf, Heindel also collected many of the less verifiable legends of witchcraft and the supernatural that are associated with the hill. Tales of bewitched firearms, strange deaths, curses, disappearing farmers and ghosts fill his pages. One of the most interesting was related by a lawyer who had a rather unique case shortly after World War I. He was approached by a man who wanted to divorce his wife because he knew she was a witch. He had allegedly seen the evidence firsthand. The man claimed that his wife got up in the middle of the night on Walpurgis Night, rubbed her face with a homemade ointment that she retrieved from her dresser drawer, mounted a broomstick and flew off after saying some words in German. The man, who had been pretending to be asleep, immediately got up and performed the same ritual. His broom carried him through the air to Hexenkopf, where he found his wife participating in some type of ceremony. She was not surprised that he followed her and directed him to a table surrounded by small demonic figures with long tails. They gave him a steaming drink, and the next thing that he remembered was waking up in his neighbor's pigpen. Even though the man seemed to believe that he had a solid case, the lawyer convinced him to resolve the matter out of court. The man's story bears a strong resemblance to the accounts of witchcraft common in Europe centuries before. It is also exactly the type of legend that would be associated with a traditional witch's mountain.

THE MANY WITCHES OF BERKS COUNTY

Berks County was home to one of the largest German populations in the state, and as a result, traditions of powwow and hex had a substantial presence there. The existence of folk magic was well established in the county by the time of the American Revolution. Anna Maria Jung, better known as Mountain Mary, of Pike Township, was probably the first well-known powwower in the state. Living as a hermit in the mountains, she practiced her healing art from the 1780s until her death in 1819. Though she was never known to practice witchcraft and had a good reputation, there were other signs of the belief in *Hexerei* dating back to the county's early

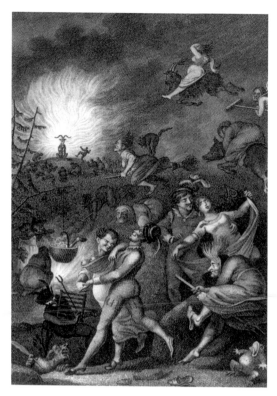

A depiction of Walpurgis Night on Brocken Mountain, the highest peak in the Harz Mountains, by Johann Heinrich Ramberg in 1829. *Author's collection.*

days.

In Windsor Township, there is a hill that has supernatural associations as clear as its name. Like Hexenkopf in Northampton, Witches' Hill was rumored to be the meeting place of covens that assembled to perform their ceremonies with the Devil and his minions. Also called the witches' dance hall, a bare spot at the top of Witches' Hill was rumored to be the precise location where the witches gathered and danced in circles. Sometimes the witches were said to have left signs of their dancing in the form of what we would now call crop circles. Like at Hexenkopf, mysterious lights were seen at the top of the hill for decades by those living in the communities around it.

Walpurgis Night was, of course, the most active such night of the year. The hill was supposedly so evil that animals were unwilling to cross over. Today one can follow the appropriately named Witchcraft Road onto the hill.

Throughout the 1800s, dozens of specific witchcraft incidents were recorded or reported in Berks. A few will be recounted here, starting with a tale from 1862. As reported in the Adams County *Sentinel*, an unnamed married woman who was forty years old had been suffering from a sore on one of her limbs for years. She lived on a farm with her husband near the Berks County and Lehigh County border. Her mother came to live with them and tried to convince her daughter that her illness was the result of being hexed. The couple did not believe her at first but were eventually convinced by her persistence. The older woman sent her daughter's husband to find and purchase a copy of *The Sixth and Seventh Books of Moses*, hoping that it

would contain a spell or charm to reveal the identity of the witch. When the book failed to be of assistance, the family turned to a local woman who was known as a powwower or hex doctor. (The article calls her a fortuneteller.) For a fee of $2.50, she promised to find the witch and remove the hex. She told all three of them to meet her in a nearby field, and each was to bring a

6 THE SIXTH BOOK OF MOSES.

MÁGIA ALBA ET NIGRA UNIVER-SALIS SEU NECROMANTIA;

That is, that which embraces the whole of the White and Black Art, (Black Magic,) or the Necromancy of all Ministering Angels and Spirits; how to cite and desire the IX. Chori of the good angels and spirits, Saturn, Jupiter, Mars, Sun, Venus, Mercury, and Moon.

The most serviceable angels are the following:

SALATHEEL, MICHAEL, RAPHAEL, URIEL,

together with the Necromancy of the black magic of the best Ministering Spirits in the Chymia et Alchymia of Moses and Aaron.

That which was hidden from David, the father of Solomon, by the High Priest

SADOCK,

as the highest mystery, but which was finally found in the year CCCXXX, among others, by the first Christian Emperor Constantine the Great, and sent to Pope Sylvester at Rome. after its translation under Julius II. Pontifice max. Typis manabilis sub pœna excommunicationis de numquam publica imprimendis sent to the Emperor Charles V., and highly recommended in the year MDXX., approved by Julii II. P. M. Cme. duos libros quos Mosis condidit arter antistis summus sedalitate SADOCK. Libri hi colorum sacra sant vota sequenter spiritus omnipotens qui uigil illa facit at est samis pia necessaria. Fides.

Instruction.

These two Books were revealed by God, the Almighty, to his faithful servant Moses, on Mount Sinai. intervale lucis, and in this manner they also came into the hands of Aaron. Caleb. Joshua, and finally to David and his son Solomon and their high priest Sadock. Therefore, they are Bibliis arcanum arcanorum, which means, Mystery of all Mysteries.

The Conversation of God.

Adonai, Sother, Emanuel, Ehic, Tetragramaton, Ayscher. Jehova, Zebaoth, the Lord of Hosts, of Heaven and Earth; that which appertains to the Sixth and Seventh Book of Moses, as follows:

Adonai, E El, Zeboath. Jebaouha, Jehovah, E El. Chad, Tetragramaton Chaddai, Channaniah. al Elyon, Chaye. Ayscher. Adoyah Zawah, Tetragramaton, Awiel, Adoyah, Chay, Yechal, Kanus, Emmet, thus spake the Lord of Hosts to me Moses.

This page from *The Sixth and Seventh Books of Moses* explains how the grimoire can be used for both white and black magic. *Author's collection.*

$5.00 gold piece. All three pieces had to be minted in the same year. After the family arrived, the woman wrapped each of the gold pieces in a different colored rag and buried them near one another in the field after reciting some incantations. She said that they would have to return in twenty-four hours to learn the witch's identity.

When they returned the next day, the woman announced the identity of the supernatural assailant. It was the couple's next-door neighbor. To prove it, she instructed the couple to place a red cloth over their door. She said that the neighbor would be the first one to ask why it was there, thus confirming her identity as a witch. This was apparently enough proof for the couple, because that is exactly what they did. Before departing, the folk magician dug up the coins, but they were missing. She claimed that her spell was so strong that it dissolved the gold. (They were probably recovered the previous evening, of course.) A few hours later, the neighbor came by and asked about the red cloth. The husband and wife seized the neighbor and began to beat her, stopping only when she promised to remove the hex and heal the sore. The bewildered woman probably confessed just to stop the beating. Unfortunately, there is no further information as to what happened after the incident.

A Strausstown woman identified as Mrs. Raymond Reichard caused quite a bit of trouble in 1885 when she began to accuse her neighbors and several prominent citizens of bewitching her ten-year-old daughter. After claiming that the individuals were attempting to supernaturally murder their enemies, the woman was briefly arrested for slandering them. Reichard was so obsessed with supernatural dangers that she spent most of her family's extra income on charms of protection provided by local hex doctors. Every month she placed new charms above the doorways and windows of her house. Mrs. Reichard also resorted to some gruesome magic of her own to stop the witches from using their powers on her. She burned snakes alive, scattering their ashes across the accused witches' doorsteps. On other occasions, she would quarter and fry live toads and proceed to eat them while uttering her own curse on the witches. Reichard was also known to cut some hair from the head of someone believed to be a witch, burn it to ashes and then spread it on buttered bread. She then took the bread and fed it to the perceived witch's dog. She believed that these practices, and others, would protect her from their hexes.

Mrs. Reichard claimed to have proof that witches were actively causing problems in Strausstown. She frequently cited an example involving a neighbor who was approached by a black cat. The cat began to rub itself

against his leg while he was working in his yard and would not go away. Finally, the man grabbed his pitchfork and stabbed the cat in the back. The animal fled, but the next day he visited a local woman thought to be a witch. The witch had reportedly taken ill, and the man was curious to see what was wrong. When he arrived, he discovered that the reported witch had a fresh stab wound in her back. From that point on, she was unable to use her diabolical powers.

Just a few years later in 1889, a story surfaced in Reading of another witch. Papers reported that about twenty years earlier, a family with a new baby was living on Cedar Street, across from a woman reported to be a witch. For the first three months, the baby was extremely pleasant and rarely cried or fussed. One afternoon, the witch came over to see the baby. She picked it up, gave it a hug and a kiss and then muttered something that seemed to be in Hebrew before placing the baby back down in the crib. After the witch's visit, the baby became irritable and broke out in spots. Whenever the witch looked out from her window across the street, the baby could not sleep. After taking the child to numerous doctors who provided little help, the family became firmly convinced that the baby had been hexed. The parents decided to hire their own hex doctor to combat the witch.

Prior to his visit, the hex doctor sent word to the family not to speak to him when he arrived. He came to their door and entered their house silently. After writing several words in Ethiopian on a piece of paper, he placed it in the Bible at a certain passage. He then placed the Bible under the child's pillow and warned the parents not to give the witch anything that she asked for. If they did this, the baby would be fine. The next day, the witch came by and asked to borrow some tea. The couple turned her away as they had been instructed. Two nights later, a black cat showed up at the child's bedroom window. The baby's father saw the cat, assumed that it had been sent by the witch and hurled his boot at it. The cat was struck and fell from the window. Early the following morning, the baby's father saw the old witch limping outside of her house. He asked what had happened, and she claimed only that she had fallen down the stairs the previous night. The father knew otherwise and was convinced that the woman was indeed a witch and had appeared in the form of a cat. After the incident, the family received no further trouble from the witch.

Around the same time, a man from Boyertown was allegedly being harassed by a witch that lived on Tenth Street in Reading. The witch was invisible to all but him, though family members could see the invisible tormentor open and close windows. It was usually late at night when the

witch arrived, and he sat on the poor man's chest and beat and pinched him mercilessly. The man could finally endure no more and traveled to Reading to find his own hex doctor to help fight the witch. The hex doctor that he consulted wrote a charm on a piece of paper, folded it up and gave it to the man along with a horseshoe nail. He told the man to get up before sunrise and nail the paper into a tree on the side where the sun falls in the morning. The man was only to drive the nail in a little, and it would be enough to cause the witch to suffer. The further the nail went into the tree, the more pain the witch would suffer. The man did as he was instructed, but the witch kept coming back. One morning, out of frustration, he drove the nail the entire way through the paper and into the tree with the back of his axe. Just as he turned, he had a vision of the witch dropping over dead. When he told his family and friends, they did not believe him and thought that he was becoming obsessed. Soon, however, they received word that the witch had indeed died in Reading, at the same time the nail had been driven in. Though the newspaper would not print the names of the people involved in the incident, their identities and stories were allegedly verified.

In the early 1890s, stories of witchcraft in Berks continued to fill the press. The small community of Greshville was associated with witchcraft, as there were said to be over a half dozen hex doctors in the area who were blamed for a variety of ailments and hexes. Though the press portrayed the hex doctors as unscrupulously taking advantage of the naïve, they were rarely without work. They were sometimes credited with healing but often causing trouble as well. Some Greshville hex doctors were even blamed for causing insanity in a local woman who came to believe that she was under the influence of evil spirits.

An 1894 report from Reading laid the death of a baby at the hands of a hex. When young William Dietrich became ill, a local powwower confirmed for his parents that he had been bewitched. Before the hex could be reversed, the baby passed away, and his body allegedly turned black a short time later. His mother claimed to have seen evil spirits floating near his bedside. She had lost another child a few years before and believed that the death was also the result of a hex.

Even in 1899, a report emerged from Reading of a witch who was harassing a young man named William Reifsnyder. The witch, who went only by the name Lazarus, appeared to the young man in the form of a cat. The witch also waited for him in human form outside of his place of employment, demanding money. He threatened that if it was not paid, he would summon evil spirits to come at midnight and tear Reifsnyder apart.

Lancaster's Witches

Like Berks County, Lancaster has been home to many witches over the years. Several accounts of witchcraft from the county were recorded in large newspapers in the late 1800s, including the *New York Times*. The lurid tales captivated readers who mocked the "superstitious" yet hung on every word. Two of those stories will be retold here. The first tale emerged from the town of Columbia in January 1878. A woman from the area was being supernaturally targeted by a witch. Her problems had begun several weeks earlier when a young lady that was working for her became ill. The woman, who was convinced that a hex was involved, took the sick girl to a hex doctor in Marietta for treatment. It soon became clear to the woman that the unidentified witch did not like her interference, and she became the target of the witch's hostility.

The next day, the woman awoke to find a small cake sitting on a chair in her kitchen. Suspecting something unnatural, the woman tossed the cake into the fire of her iron stove. The following morning she discovered a small jar full of liquid on the same chair. She carefully hid the bottle in her house, in case it would be needed for some magical purpose. On the third day, the woman discovered a piece of hard candy on the chair. Once again she tossed it into the fire. In the days that followed, more bottles appeared, but strange things began to happen. Every time the woman hid a bottle, it would mysteriously vanish. She came to believe that the invisible witch was removing the bottles through the chimney while she slept.

Strange noises also started to be heard around her home. The sounds of cats crying and women sobbing shattered the tranquility of the house. The woman decided to return to the hex doctor to seek additional help. The hex doctor created a "preparation," described as resembling chloride of lime, which was to be burned in the stove on that evening when she returned home. An unidentified young man volunteered to help with the ritual, and no one was allowed to open a window or door and leave the house until the following morning.

Unfortunately, the treatment failed to be effective, and the torments of the witch became worse. The invisible assailant began to physically assault the woman, throwing her around the room, choking her and tossing her to the floor. The woman claimed that at first the witch's touch would be cold, but then it became burning hot. Marks that resembled burns seemed to appear on her skin after the assaults. The witch's touch would cause pain to shoot through her entire body. After several days of assaults, the

woman was confined to her bed and was described as being on the verge of insanity.

Even in bed, the woman was harassed. A fiery hand appeared in front of her face, and a strange black cat tried to gain entry to her room through the window. Noises were heard every night, described as the sound of sticks banging together and horses' hooves pounding on her wooden porch. One of the woman's healthy hogs died mysteriously around this time. The press provided no follow-up to this strange story, so we do not know how and if she ever fended off the

Berks and Lancaster Counties make up the heart of Pennsylvania Dutch Country. Many tales of witches, hex doctors and folk magic have emerged from the region since the 1800s. Both counties are shown on this map from 1890. *Author's collection.*

magical assault, but at the end of the story, the paper did print the opinion of the woman's medical doctor. He believed that the marks were a result of some kind of skin infection or disease and reported that the woman suffered from occasional epileptic fits since childhood. The doctor was convinced that her medical conditions were more than sufficient to explain her bewitchment.

Another tale of hex from Lancaster was discussed in an 1885 issue of the *New York Times*. A former resident of the county spoke to one of the paper's reporters and recounted tales that he remembered from his time there. One involved a wealthy farmer named Saulus Fenner, who had become convinced, for an unknown reason, that treasure was buried on his property. Fenner decided to consult a hex doctor to help him find the buried fortune. He chose an old woman known for her abilities in such matters, and she assured him that he was correct in his belief. She also promised to help him find the treasure if he followed her instructions exactly. Fenner did not suspect the unscrupulous nature of the witch that was helping him.

The old woman had the man bring a bundle of fifty $100 bills to her house. Carefully, the old woman tied them up in a cloth with witch hazel, bread crumbs and the burned hair of a white horse's tail. She ordered Fenner to return with the bundle each day for seven days. When he came back, she untied the bundle, let him count the money, and tied it back up. On the seventh day, after reciting some incantations, the old woman started to convulse. She soon announced that the protective spell on the treasure that prevented it from being found was broken. She took the cloth bundle and added more herbs and materials before giving it back to Fenner one last time. He was to bury the bundle in the corner of his basement, cover it with pine shavings and wait seven more days. When he dug it up, the bundle would contain instructions on how to find the treasure.

Fenner waited anxiously for a week and finally dug up the bundle on the seventh day. When he opened it, he found no instructions and discovered that his money had been replaced with brown paper. He immediately went to the old witch's house, only to find it abandoned. He never recovered his $5,000.

Moll Derry, the Witch of Fayette County

Mary "Moll" Derry was probably the most well-known witch of the western half of the state. Sometimes known as the "Fortune Teller of the Revolution" or the "Witch of the Monongahela," Derry had already become a legend

before her long life ended. Born sometime around 1760, Derry came to America with her husband, Valentine, who was supposedly a Hessian soldier. The Hessians were Germans hired in units as mercenaries to help the British fight during the American Revolution. Valentine defected from his unit, and after fighting for the American side, he and Mary moved across the Appalachians to the Pennsylvania frontier. They lived in Bedford County during the 1780s and then in Fayette County from the 1790s onward, making their home near Haydentown in Georges Township. "Old Moll" quickly established a reputation of having supernatural power and was probably what we would consider a hex doctor. She was well known for predicting the future, curing ailments and, more maliciously, placing curses. Both respected and feared, Derry held a unique place in the community.

Numerous stories have been recorded about Derry, and she was even represented in some regional literature during her lifetime. Some of the stories have minor detail variations, as can be expected when they are retold over and over. The main elements of the tales are consistent. Moll lived until 1843, so she had many years for her reputation to build and spread. As for her physical appearance, there were a variety of descriptions. Sometimes she was described as being so petite that she slept in a cradle with rockers running lengthwise. On other occasions she is described as a much larger woman. Chances are that her physical appearance probably changed throughout her life, so it is natural that there would be different accounts of her appearance.

One thing is certain; Moll Derry was not a woman to be crossed. If a neighbor angered her, he would soon find that his animals might get sick, his bread would not rise and his cows would not produce milk—and that would be a mild punishment. On one occasion, in the mid-1790s, Derry ran into three men who mocked and taunted her about her rumored abilities. Derry supposedly looked coldly at the men and told them that they would all hang. It did not take long for the first man, whose name has been given as either McFall or Butler, to succumb to the witch's curse. In 1795, he killed a man in a drunken fight and was quickly arrested, tried and hanged. The second man, whose name is usually given as Dougherty, robbed and murdered a peddler who was passing through Fayette County. He fled to Ohio, where he committed another murder. He was quickly caught and eventually confessed to both murders. At his trial in 1800, he was sentenced to death and was hanged. The third man, who was named Flannigan, had heard of the demise of the other two and remembered Moll Derry's curse. In despair, he crossed over into Greene County and committed suicide by hanging himself.

Another popular account of Derry's power tells of an incident that occurred around 1818 or 1819. A peddler from New Jersey was passing through Smithfield when he ran into an old acquaintance that now lived in Fayette County named John Updyke. The peddler told Updyke that he had heard of Moll Derry and wanted to visit her to have his fortune told. Updyke told the man that he could lead him to her home near Haydentown. Instead, he led the man back to his cabin, where his friend Ned Cassidy was waiting. The pair robbed and murdered the peddler, carried his body through the woods in the darkness of night and tossed it in a millpond. Though a trail of blood was discovered in the woods, it did not lead back to Updyke's cabin and could not be linked to the two men. Within a few days, Cassidy's conscience got the better of him, and he found that he could no longer sleep. Tormented by guilt, Cassidy decided to approach Moll Derry to see if there was anything that she could do or give him to help him sleep.

A map from an 1872 atlas depicting the Haydentown area in Fayette County. Moll Derry, the Witch of the Monongahela, lived in the area from the 1790s to the 1840s. *Courtesy of the Library and Archives Division, Senator John Heinz Pittsburgh Regional History Center.*

Derry allegedly fixed her eyes on him with an evil glare and said, "Why are you coming to me when your hands are still wet from your dirty work at the mill pond?" Shocked and frightened, Cassidy quickly walked away. Updyke would not be as lucky.

At the time, Derry was training an apprentice named Hannah Clarke who lived about a mile away from Updyke. One afternoon, shortly after the murder, a prominent local citizen paid a visit to Clarke. When he was leaving, he noticed a drawing on the back of her door that vaguely resembled Updyke. The man took notice of a nail protruding from the drawing's head. It had appeared to have been tapped in only once or twice. When he asked Clarke about it she explained that if she drove the nail the whole way into the drawing, Updyke would die. Instead, she was going to tap it in slowly, a little at a time, so that Updyke would suffer for the crime he committed. The man decided to investigate on his own, so he walked up the road to Updyke's house and paid him a visit. Sure enough, Updyke was complaining about a sharp pain in his head. The man, now believing in Updyke's guilt, said nothing and went home. The man checked back occasionally with Clarke to see if she had driven the nail in. Clarke dragged the process out for weeks until Updyke was in so much pain he could not get out of bed. He finally confessed to the crime as he writhed in pain. The next day, Clarke drove the nail the entire way in, and Updyke died.

Moll Derry would become associated with many other tales of the unusual and supernatural, including the death of Polly Williams at the White Rocks. She allegedly predicted the murder of the young woman at the hands of her fiancé (for a full account of that story, see my book *Ghosts of Southwestern Pennsylvania*.) Even after her death, Derry continued to surface in fictional accounts and regional histories.

Identifying a Witch in Montgomery County

In 1880, a report surfaced in some Pennsylvania newspapers of a young man's efforts to identify a witch. His wife had recently become ill, and for some unknown reason, the man was convinced that she had been bewitched. He took it upon himself to identify the source of the problem. First he retrieved a brand-new horseshoe from a local blacksmith. He then prepared it in an unidentified way to act as a charm. When he was finished, the man cast it into a fire and waited. Soon after, he learned that one of his neighbors

was suffering from a burning pain in her chest. Believing that he had found the witch, and to confirm his diagnosis, he spread a line of salt under the carpet at his front door. Many friends passed over without incident when they came to visit his sick wife, but the suspected witch stumbled when she crossed the salt. The report concluded only by saying that the young man was going to conduct further tests, and it is not clear what action he took to end the hex.

WITCH DOCTORS CONVICTED IN CUMBERLAND COUNTY

An unscrupulous hex doctor from Carlisle named Sarah McBride and her accomplice Edgar Zug ran into legal trouble in September 1902 after repeated consultations with an elderly couple. McBride and Zug had convinced Frank and Susan Stambaugh in 1900 that they and their property had been bewitched. McBride claimed that she could remove the hexes for a small fee. She and Zug also told the couple that there was buried treasure on their property with a value of $30,000 dollars, and that if the curses were removed, they could use magic to find the treasure. The Stambaughs paid the pair over $500 dollars over two years for their services.

When the Stambaughs finally became suspicious, McBride informed them that their profiles had been traced onto a mountain, and each of their heads had a rusty pin placed in it. She warned them that if the pins broke, they would die. To remove the pins, they needed more money. By this point, the elderly couple was out of money and had to turn to family and friends to borrow funds. Realizing what was going on, the friends told them to stop paying immediately and report McBride and Zug to the authorities. The hex doctor tried one last time to get money out of the couple, telling them that they would die if they did not pay. However, criminal charges were brought against McBride by that point, and she was held for trial for fortunetelling and taking money under false pretenses.

She claimed only to be a simple powwower, but a substantial amount of testimony was presented against her. Though newspaper headlines presented it as a witchcraft trial, the case was really about defrauding the Stambaughs. McBride was convicted on September 11, and the case quickly faded from the news.

LAWRENCE COUNTY WITCHCRAFT

Tales of witchcraft were passed down well into the twentieth century in Lawrence County. Esther Black, who was a professor at Ashland College in Ohio, collected several of them from the southern part of the county in the early 1960s. One account took place in what are today New Beaver and Little Beaver Townships. According to the story, a mysterious old woman caused problems for the farmers of the area in the late 1800s. The woman is never identified, but the locals believed that she was responsible for a variety of annoyances. Every time that she would pass by, strange things would happen. Cows would not produce milk, fires would not light, cream would not churn into butter and bread would not rise. The old witch was even blamed for the misbehavior of the children. A cattle buyer from New Castle named Wettich also had trouble with the old woman. Every time he tried to drive his cattle past her home, the animals would be spooked and turn back. No amount of force or coercion could make the beasts pass the house. It happened so often that Wettich was forced to change his route.

Two other stories emerged from the Enon Valley, an area originally populated by farmers of German descent. The first emerged from a dispute between two families. It began one day when the daughter of a farmer crossed the field of a neighbor to go to a mailbox. The young woman encountered her neighbor and apparently said something that he found insulting. The angry farmer responded by giving her several lashes with his whip. After hearing about the incident, the young woman's father brought the matter before a local judge. The case was decided in his favor, but it is not clear what kind of punishment the angry neighbor received.

Almost immediately after the case was resolved, strange things began occurring in the young woman's home. At night, the family would hear noises throughout the house. In the morning, they would discover that locked doors were open, dishes were broken and furniture was overturned. Nothing was ever stolen, so burglary was ruled out as a cause, and the locks had been opened from the inside. After several weeks of such torment, the girl's father and mother approached a man locally known as a "witch" who was probably a traditional powwower or hex doctor. The hex doctor collected water from his spring and mixed it with certain herbs while reciting a German incantation. He gave the mixture to the family and ordered them to dip the branch of a cedar tree into the water and use it to sprinkle the concoction onto every door, window and possible entrance to the house. When the family did this, the supernatural activity in their house stopped.

Another unusual cure was recorded in the same area, possibly provided by the same witch. In that case, a woman who was ill came to the witch to find out if she had been hexed. The witch confirmed her fears and then prescribed an interesting remedy to remove the spell. He directed the woman to sweep her entire house from top to bottom and collect the sweepings. They were to be placed in a red flannel bag along with fifteen pins. Nine of the pins were to be placed in the bag point up while the others were placed point down. None could stick through the flannel. The bag was to be tied shut with a rope, hung from a tree branch and beaten with a club (as if it were a magical piñata.) This aggressive treatment seemed to work, because the woman believed that the hex was lifted.

A WITCHCRAFT ACCUSATION IN FULTON COUNTY

The *Chambersburg Whig* reported on an alleged religious inquiry into a case of witchcraft near Sideling Hill in Fulton County in February 1853. Members of a small local religious group, called only the Christian Church, took it upon themselves to determine if there was a witch in their midst. One of the members of the church had been ill for some time and was failing to show any signs of improvement. It is not explained how, but she came to believe that she had been bewitched by another woman in the congregation. The article names neither woman but describes how the congregation dealt with the accusation.

The minister called a church meeting to formally address the charges against the alleged witch. Since there were no rules or procedures for dealing with such an accusation, it took a while to determine a course of action. What they decided on sounds similar to the tests that were used in the Mount Holly hoax. First, the woman was made to step over a broomstick. It was believed that a witch could not do so. The accused witch passed over the broom easily, of course. As a second test, the congregation decided to weigh her on a scale against the Bible. As stated earlier in the book, it was believed that a witch would be lighter that the Bible. The woman stepped on the scale at a nearby mill, and the Bible quickly lifted into the air. Some in the congregation believed that her clothing was making her too heavy and skewering the results, so half a bushel of corn was placed on the scale with the Bible to even it out. The woman again stepped on the scale and was still heavier than the Bible. The congregation dismissed the charges against the woman.

Strange Tales from Somerset County

Several brief accounts of witchcraft in Somerset County were recorded in the *Somerset Herald* in 1892. They were told by an old man referred to only as "Uncle Joe" who had grown up in the area in the early 1800s. All of the incidents occurred during his youth. Joe's details were sparse, but it is clear that the beliefs common in other parts of the state had also arrived in the county with German settlers. His first story tells of an unnamed family that was being harassed by a witch. The specifics are not discussed, but it was bothersome enough for the family to turn to a hex doctor for help. The hex doctor came to the family's home and prepared to cancel out the witch's spell. While reciting some charms, the hex doctor took a needle and bent it until he was able to pass the tip through the eye. The next morning the family found the suspected witch doubled over in pain (basically taking the shape of the bent needle) and lying in a manure pile. The witch did not bother them again.

An Amish barn raising in Somerset County in the early twentieth century. Though the Amish were generally not practitioners of powwow, they were only one of many German religious sects that spread out across the state. Many Germans of a variety of religious backgrounds settled in Somerset, and some brought traditions of witchcraft with them. *Author's collection.*

Joe also recounted the tale of a man who was frequently being "ridden" by a witch. The witch would come at night and climb on top of him. Not only would the witch assault him in his bed, but she would also somehow transport him out to a road near the fields and continue to ride him like a horse before leaving him hitched to a post. When he awoke in the morning, he was back in his bed. After being ridden several times, the man attempted to mark the spot in the road where he had been hitched by his tormentor so that he could return and inspect the site in the morning. Despite his best efforts, the man could never remember exactly where he had been the previous night or how he returned to his bed.

The account sounds very much like a case of sleep paralysis, sometimes known as the "Old Hag" syndrome. Over the centuries, this biological phenomenon has been attributed to witches and supernatural entities. Sleep paralysis occurs when the body is in a twilight state between being fully asleep and fully awake. The mind, believing it is awake, experiences hallucinations or vivid dreams. The body seems paralyzed, but it is because it has not been told by the brain to move. It is usually accompanied by the feeling of pressure on the chest and could give the feeling of being "ridden." The occasional hallucinations could manifest as a witch-like figure or demon, giving the impression of a supernatural assault.

Yet another strange occurrence was reported at a house near West Salisbury. One nice day, a young man who lived in the area decided to visit four young ladies who lived at their parents' home nearby. As the young man walked up to the house, he noticed that there were four black cats on the roof acting strangely. As he continued to stare, the cats vanished right before his eyes. The man then hurried to the front door and discovered that the young women were on their way down the steps to meet him. They looked as if they had recently been outside and mentioned that they had just returned from a walk. The young man, suspecting that the girls were witches, did not stay long.

Another story recounted in the article involved a man named John Summy. When he was a young man, Summy had decided to pay a visit to a woman who lived alone with her children on the other side of Negro Mountain. Rumors had circulated that she was a witch, but Summy did not believe them. The woman, who seemed to be attracted to him, was very hospitable and convinced him to stay for dinner. When they were finished eating, she tried to persuade him to stay overnight. Summy insisted that he had to leave, and he noticed a sharp change in the woman's mood. She was clearly not happy with his decision, and now Summy feared that perhaps the rumors were true.

When he left her house, conditions were good for the long walk home. There was a full moon and a fresh fall of snow to reflect its light. After walking a little while and reaching a clearing, Summy heard a noise above his head. He looked up to see a flock of wild ducks circle around and land on a small earthen mound nearby. Sensing that something was wrong, Summy tossed a stick at them. Instead of flying away, the birds simply vanished. Summy was now in even more of a hurry to get home and away from the witch. He took a path that led two miles through the woods to the next farmhouse. Once on the path, the woods around him became very dark, despite the full moon. All around he heard what he described as the "wailing" of cats. Surrounded by the surreal conditions, fear finally overtook him, and he ran the rest of the

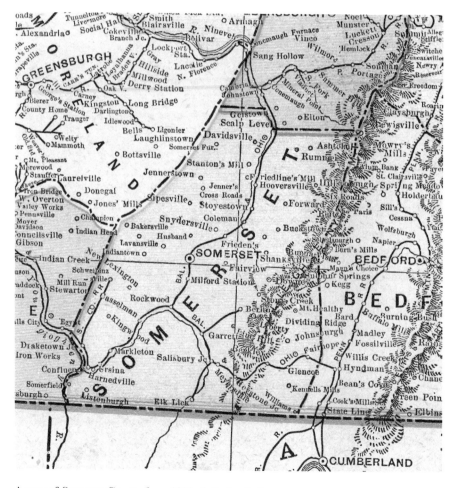

A map of Somerset County from 1890. *Author's collection.*

way to the farmhouse. He stayed there for the night and, in the morning light, returned to find any trace of the cats in the snow. He found no tracks but his own. Convinced of the woman's powers, Summy avoided her after that night.

The *Connellsville Keystone Courier* reported another case of alleged witchcraft in February 1883. Jesse Miller, a farmer in Greenville Township, was insistent that his family was being supernaturally harassed by a witch. Objects mysteriously moved around inside his house when there was no one around. A saddle was removed from a hook near the chimney three times. Another incident occurred when his wife was folding laundry. She stepped outside of the house for a few minutes in the middle of the task. When she returned, she found the laundry scattered about the room. The most frightening supernatural harassment appeared to be directed at his daughter. Twice she was thrown from her bed by an invisible supernatural force in front of witnesses. Though the adults could not see the witch, the girl claimed to see her when she was attacked. She described the attacker as "an old woman with hoary locks, a hairy face, and wearing a thin white cap." The article stated that the family was going to recruit the help of a local witch doctor to help them against the malevolent magic of the witch. Since there was no follow-up, we do not know how this case was resolved.

Dauphin County Witches

At least two tales of suspected witches have survived from the early 1880s in Dauphin County. One alleged witch lived in Harrisburg in an alley just off Liberty Street. We know of the woman from an 1882 article in the *Harrisburg Telegraph* titled "A Modern Witch." Though her name is not mentioned, she is described as an old woman who openly spoke of her supernatural powers. When entering her own home or another structure, she leapt back and forth through the doorway repeatedly before going in, as if performing some strange ritual. Her neighbors reported that she was constantly muttering incantations and charms. She also allegedly bragged about her powers to spread or cure disease. The people who lived in her neighborhood seemed to really believe in the witch's power. The article cited one woman who claimed to have suffered from the wrath of the witch. She stated that her children, whom the witch did not like, would catch every childhood disease and illness while their friends and other neighborhood children never got sick. The woman felt that the witch was directly responsible for the illnesses.

The unknown author of the article, after ridiculing all of their beliefs, stated that the witch seemed to enjoy the fear that her reputation brought.

Another witch tale, this one from Stony Creek in Middle Paxton Township, was uncovered by Pennsylvania writer and researcher Stephanie Hoover. A young woman named Emma Gilday (sometimes spelled Kilday) was about to walk home from church one day when a young man asked if he could accompany her. The young man obviously liked her, but she did not feel the same way and turned down his offer. The young man did not handle the rejection well, and he declared that he would seek the help of an alleged witch named Mrs. Boyer to cast a fatal spell on her.

Gilday's parents were believers in the power of witchcraft, so when Emma fell ill, they suspected that the young man had done exactly what he had threatened to do. After several traditional medical doctors were brought in without success, the family turned to a hex doctor named Wolf. Wolf confirmed what they had feared and allegedly made an image of the witch, Mrs. Boyer, appear in a basin of water. William, Emma's father, turned to another hex doctor named Armstrong McLain for a cure. McLain performed a ritual that involved burning hair on a shovel. He told William that if he did not see a brindle cow as he traveled home, his daughter's condition would improve by nightfall. Emma showed improvement for a while, but in 1881, she became ill again. McLain was summoned to the Gilday home to see what could be done. The hex doctor performed what he claimed to be a ritual that would kill the witch. He lightly touched a hammer to Emma's temple and announced that Mrs. Boyer would soon die.

Mrs. Boyer did not die, and her family was becoming very upset with the accusations being laid against her. Her son John filed an anti-defamation suit against McLain, and the matter was held over for trial. However, before the case went to court, the Boyers decided that it was best just to move away. Bad luck continued to follow the Gildays. William died a few years later in 1884, and Emma's first husband died at the young age of twenty-eight.

A TROUBLESOME WITCH IN VENANGO COUNTY

Sometime during the 1840s or 1850s, a brief witchcraft scare arose near Sunville in Venango County. The story of the scare was related by Joseph Kean in 1879, and he was purposefully vague on the names and exact dates because many who were involved were still alive at the time of his retelling. The tale began with a

young woman of "respectable parentage" who began suffering from fits and at times seemed "partially deranged." She claimed to have a roaring in her ears and double vision during the fits. The girl's parents initially assumed that she was suffering from some type of disease or illness, but as word spread of the girl's condition, people in the neighborhood came up with their own ideas. Multiple people approached the family and tried to convince them that their daughter had been bewitched. The neighbors even thought that they had identified the witch, who was a reasonably well-liked Irish woman who lived nearby.

After being subject to the relentless prodding of their friends in the community, the family finally consented to use traditional folk remedies against the witch to help their daughter. They contacted several "witch doctors," who were actually probably powwowers of some sort, but their remedies and incantations failed to help. Horseshoes were placed over entrances to the house, and knives and sharp objects were placed in every opening, but that, too, failed to deter the witch. A man named George Shunk, who was a seventh son, was brought in to observe the girl during her fits or "attacks." It was thought that the purity of his birth could drive out any demon or spell afflicting the girl. When the attacks came, Shunk instructed the girl to point in the direction of her invisible attacker. As the girl twitched and writhed, Shunk swung a heavy club through the air around her. The witch seemingly dodged every blow, and Shunk looked foolish as he flailed about. A hardened old veteran of the War of 1812 witnessed the display and boldly stated that he was not afraid of the witch. He told the girl to get a cup of water, which she did, and then ordered her to drink it. She claimed that she could not because the witch would not allow her. The old veteran insisted that he could deal with the witch if she interfered, and the girl drank the water without incident. Instead of diffusing the situation, some of the neighbors began to accuse the old veteran of being the witch and even threatened him with physical violence.

Another family friend suggested a different strategy in dealing with the supernatural oppressor. He believed that the witch would be unable to cross moving water, so the family relocated the girl to the other side of Sugar Creek near Dempseytown. The problems continued, however, and it was surmised that there must have been debris in the creek that the witch could use to cross. When the creek was searched, a fallen hemlock log was discovered that served as a bridge. By this point, the witch became the most-discussed topic in the community. People visiting the girl's house claimed to have seen evil spirits and other strange things lurking around the property. Finally, a man was brought in who had claimed to be a witch killer back in Germany.

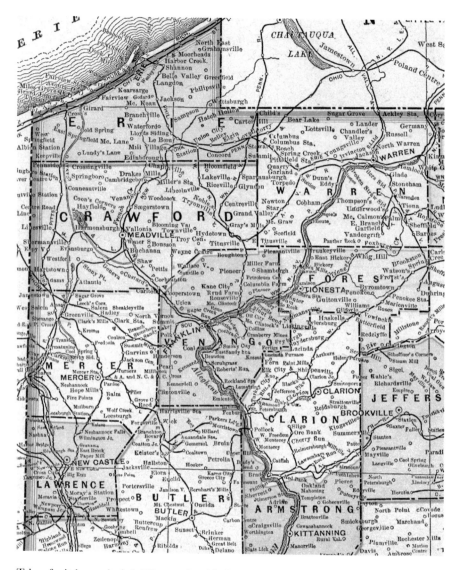

Tales of witches and witch killers surfaced in Lawrence, Venango and Warren Counties in the 1800s. All three counties are shown on this map from 1890. *Author's collection.*

It was hoped that he could put an end to the girl's torment. He visited her several times, often while intoxicated, to drive out the witch. All of his efforts were unsuccessful, and he finally declared that American witches were "too cunning" before he gave up.

With no end to the witch's attacks in sight and his or her identity again uncertain, people who had visited the girl began to report strange happenings

at their own farms. Cows and pigs mysteriously became ill and died, and neighbors started to accuse each other of witchcraft. Eventually, cooler heads prevailed, and those accused of practicing the dark arts began to file lawsuits for defamation of character. The threat of legal action was enough to end the scare over the witch. The girl at the center of the scare finally received medical treatment from a trained physician, and her condition improved. She later stated that the only reason that she thought that there was a witch attacking her was because of all the adults who told her so.

THE WITCH KILLER OF WARREN COUNTY

There is not a tremendous amount known about John Meyers, who supposedly lived along West Spring Creek in Warren County in the earliest decades of the nineteenth century. Pittsburgh folklorist, writer and historian George Swetnam collected legends about Meyers in the mid-twentieth century. Most of what we know comes from his research and from the book *Old Time Tales of Warren County*, written by Arch Bristow and published in 1932. Until his death in 1821, Meyers was sought out by the hexed and bewitched because of his unique talent: the ability to kill witches and break their curses.

Meyers, who was probably of German descent, appeared to use a variation of a method commonly used by powwowers in the eastern part of the state. It is probable that Meyers was a powwower or a hex doctor himself. When a person who believed that they were bewitched came to Meyers, he made them stand in front of a piece of paper that was tacked to the wall. He proceeded to light a candle, which cast the shadow of the bewitched individual onto the paper. Meyers would carefully trace the outline of the individual's silhouette on the paper. After carefully cutting out the shape, he attached it to a thick pinewood plank. Next, the witch killer loaded his pistol with a silver bullet, carefully aimed and fired at the outline of the bewitched person. When the bullet passed through the paper, the witch would die and the hex was lifted. Meyers was always careful to use the smallest amount of gunpowder possible so that he could recover his bullet from the pine board.

It seems that Meyers was paid well for his services, either in cash or goods. According to Swetnam, he must have done quite a bit of business because of the prevalence of witchcraft and folk magic in the county. Though the accounts are vague, they show the widespread belief in magic. Several old

women were believed to possess supernatural knowledge and would prepare charms to cure sickness, remove warts, rekindle lost love and heal or hex animals. Swetnam cited one incident in 1810 where a man approached one witch to remove the curse of another. Believing that the only way to end his string of bad luck was to submit to the witch's suggested treatment, the man allowed himself to be severely whipped and beaten with a hazel stick. A severe cure was needed to remove a severe hex. It is not known if his luck changed after the "treatment."

The belief that animals were being bewitched was so common that a method was used by farmers to remove hexes that did not involve seeking the help of another practitioner of folk magic. It was thought that if they could hold the animal under the running water of a stream or river long enough (without drowning it of course) the hex or curse would be broken. Animals could also warn a farmer of the presence of witches. It was believed that if an owl hoots repeatedly, night after night near a house, there is a good chance that a witch is around. Witches were also blamed for extinguishing hearths over the long cold winters. Normally the fire in a hearth would be maintained and burn all season. If it mysteriously went out, it was often believed that a witch had come down the chimney and tampered with the fire. As a result, many homes had a horseshoe or similar charm on the fireplace to try to ward off the unwelcome visitors. Such practices were common not just in Warren County but throughout the state.

Killing a Witch in Susquehanna County

In early 1902, a family in Forest City became severely ill. The father decided to consult a local powwower to help them. The powwower determined that the family had been hexed and prescribed a remedy to end the bewitchment. He ordered the father to drive a nail into the sill of his barn door with a single blow for three successive mornings. The man did this, but his family did not get better. They called in a traditional doctor to treat the family, who gradually improved. Though the family did not seem to be helped by the nails, it did seem to have a substantial impact on the suspected witch, who was an old woman who lived in the neighborhood. It seems that at the very same time that the third nail was driven into the sill, the old woman died. People in the community attested to the fact that the powwower's ritual had indeed killed the witch.

Chapter 4

The Hex Murders and Their Aftermath

A pair of killings that came to be known as the "Hex Murders," and the subsequent hex scare that followed, marked a substantial turning point in the way the public perceived the practice of powwowing in Pennsylvania. In the early twentieth century, prior to the two famous murders in York and Schuylkill Counties, the belief in and practice of powwow and witchcraft in Pennsylvania came to be viewed by the press and intellectuals less as a quaint holdover from less sophisticated times and more of a threat. In the past, its practitioners were often considered backward or ignorant, but not always a potential danger. That would change as the Progressive Era medical professionals sought to educate the citizens of Pennsylvania and eradicate such practices. These university-educated doctors believed that the false treatments prescribed prevented the sick from getting the scientific medical care that they needed. In the worst cases, doctors believed that the treatments would actually cause harm, and they showed little respect for traditional methods of healing. During that era of industry and progress, there was little room for the superstition of the masses. From the 1890s onward, portrayals of powwowers and hex doctors in print became increasingly critical. In an attempt by the medical profession to crack down on the "quack" doctors, medical doctors succeeded in lobbying the state government to pass the Medical Practices Act of Pennsylvania in 1911. This act helped to legally clarify who could legitimately practice medicine and provided more of a legal framework to pursue and prosecute folk healers. After the York Hex Murder, the dangers of the "superstitious" beliefs seemed readily apparent

and lent a sense of urgency to this crusade. All folk healers were viewed by the media and medical establishment in the same way as witches—a threat to the social order. They were blasted for their unscientific practices, and the belief itself was viewed as cult-like. As for the general public that prided itself on a modern, industrialized Pennsylvania, it came as a surprise for many to learn that they still lived in a world of witches.

THE MURDER OF NELSON REHMEYER

As the first and most famous of the Hex Murders, the strange killing of Nelson Rehmeyer came to captivate the public in Pennsylvania and around the country. The story of the murder begins with a young powwower named John Blymire (also spelled Blymyer.) Blymire, who was born in 1895, had learned the art and secrets of the German folk healers at a young age. His ancestors had been powwowers for at least three generations, and probably longer. Though he was considered slow in school, young Blymire established quite a reputation in his home county of York. Starting at the age of seven, he provided healing remedies and cures. It was clear that his worldview was a supernatural one, and despite his early success, he came to feel as if there were a shadow hanging over him. One day, while leaving the cigar factory at which he was employed, an apparently rabid dog began to come toward his coworkers. Blymire approached the dog and spoke the words of a spell or blessing. The dog's mouth quickly stopped foaming, and the animal became more subdued. Blymire patted its head, and the animal followed him excitedly for several blocks. The other workers were amazed at his abilities and the apparent cure. But Blymire's luck began to turn. He soon became ill, and the young man began to believe that another practitioner of folk magic had placed a hex on him, possibly out of jealousy. He found himself unable to eat, sleep or continue to practice as a powwower. Blymire used several of his own magical charms and incantations to try to remove the hex, but he was unsuccessful. It was difficult to remove a hex if one did not know the identity of the witch who placed it.

Then, one night while he was lying awake in his bed, the answer came to him. Just as his clock struck midnight, an owl outside hooted seven times. It was then that Blymire realized that he had been hexed by the spirit of his great-grandfather Jacob, who had been a powwower and the seventh son of a seventh son. Since he was unable to directly fight back against his great

grandfather's spirit, he decided to move away from the family home and the graveyard in which Jacob was buried. It seemed to work, and Blymire moved on with his life.

To supplement his income as a folk healer, Blymire worked a variety of odd jobs. Soon he met a young woman named Lily, and they married. The couple had two children, but both died in infancy. The youngest lived for only three days before passing away. These terrible occurrences led Blymire to once again believe that he had been hexed. Unable to determine the source of this new hex, Blymire turned to other powwowers for help. One of these was a man named Andrew Lenhart. Lenhart convinced Blymire that the source of the hex was someone that he knew well.

The revelation caused Blymire to become suspicious of everyone around him, even his wife. Lily had reason to be worried, because in 1922, one of Lenhart's other clients murdered her husband after receiving similar advice. Sallie Jane Heagy shot her husband, Irving, in bed after Lenhart was hired to drive the "witches" from her home. Sallie did not believe the treatment worked, and she was in terrible physical pain. She snapped, killed her husband and later committed suicide in jail. (A similar occurrence happened in July 1928, just before the Hex Murder. Another of Lenhart's clients shot her husband after receiving his advice.) After consulting lawyers, Lily was able to obtain a judge's order to have Blymire mentally evaluated. It was determined that he was obsessed with hexes and magic and should be confined to a state mental institution for treatment. As a result of the assessment, his wife filed for and later received a divorce. Blymire did not stay at the institution long, and after forty-eight days, he simply walked out because of lax security.

With no one looking to return him to the mental health facility, Blymire went back to the cigar factory to work in 1928. While working at the factory, he met two other people who also believed that they were suffering because someone had hexed them. One was fourteen-year-old John Curry. Curry was from an abusive household and felt that a malevolent force was causing the turmoil. Another man who felt he had been hexed was a farmer named Milton Hess. Hess and his wife, Alice, had been successful and prosperous until 1926, when a string of bad luck began at their farm. Crops failed, cows did not produce milk and the farm began to lose money. The entire family believed that they had been hexed by someone, but they had no idea who. The talk of hexes reinforced Blymire's own belief that there were evil forces out to get him. He began to consult other powwowers again, attempting to identify the source of his lingering curse.

This time Blymire turned to a well-known powwower named Nellie Noll (also spelled Knoll or Knopt). The elderly Noll was also known as "The River Witch of Marietta." Noll identified the source of Blymire's curse as a member of the Rehmeyer family. When Blymire asked which one, she told him to hold out his hand. She placed a dollar bill on his palm and then removed it. When Blymire looked at his hand, an image appeared. It was Nelson Rehmeyer, an old powwower whom Noll described as the "Witch of Rehmeyer's Hollow." Blymire had known Rehmeyer, who was a distant relative, since he was a child. When Blymire was five years old, he had been severely ill. Unable to cure him with their own powers of healing, Blymire's father and grandfather had taken him to Rehmeyer, who was apparently able to heal the boy. After a second visit to Noll, the river witch confirmed that Rehmeyer was also the person responsible for the hexes on Curry and the Hess family. Blymire revealed his findings to the other two men, as well as the solution for ending the hexes. Noll had instructed that the men needed to take Rehmeyer's copy of *The Long Lost Friend* and a lock of his hair and bury them six feet underground.

Blymire and Curry decided to travel to Rehmeyer's Hollow and attempt to retrieve the needed items. On November 26, the pair was driven by Hess's oldest son, Clayton, to the vicinity of Rehmeyer's Hollow. They stopped at the home of Rehmeyer's former wife Alice, who informed them that Nelson could be found at his home, which was about a mile down the road. The men went to Rehmeyer's door, and Blymire asked if he could speak to him. The older man was much larger and "meaner" looking than Blymire had remembered. They went into his parlor, where Blymire asked him questions about *The Long Lost Friend* and other aspects of powwowing. Neither Blymire nor Curry mentioned their true reason for being there. After talking for a long while, the men realized that it was late, and Rehmeyer offered to let the men sleep downstairs. Blymire and Curry hoped that they could find the book that they sought while he was sleeping, but they were unsuccessful. The men were afraid that Rehmeyer's size would make it too difficult to hold him down and cut a lock of hair. The pair left in the morning, having decided that they needed additional help.

Blymire told Milton Hess that he needed a member of his family to help them subdue Rehmeyer. Milton and his wife decided that their eighteen-year-old son Wilbert would go with Blymire and Curry. The next evening, November 27, the trio arrived at Rehmeyer's kitchen door. Rehmeyer let the men in, and they proceeded to the front room. While his back was turned, the men tackled him to the floor and attempted to

A photo showing the home of Nelson Rehmeyer, probably from the 1920s. *Courtesy of the Stewartstown Historical Society, Stewartstown, Pennsylvania.*

tie his legs with a rope that they brought with them. The exact details of what happened vary slightly depending on which of the three men told the story, but during the struggle, they beat and strangled Rehmeyer to death. It is possible that Blymire may have intended to kill Rehmeyer once he had reached the house that evening, but the younger men were not aware of this. When they realized what they had done, they took all of the money that they could find in the house. Since Rehmeyer was dead, Blymire felt he no longer needed the book or the hair. They doused his body with kerosene from a lamp and lit it on fire, hoping that the blaze would spread throughout the house and burn it down. When the trio left, Rehmeyer's body was on fire. Somewhat mysteriously, the fire seemed to extinguish itself after they left. J. Ross McGinnis, foremost expert on the York Hex Murder, believes that it is possible that Rehmeyer may not actually have been dead when the trio set him on fire, making his death that much more gruesome. Because of the position in which his body was found, Rehmeyer might have moved to extinguish the flames, but too much damage had already been done for him to survive.

The Rehmeyer home in late November 1928, just after the Hex Murder. Some damage from the fire is visible, and the door is boarded up. *Courtesy of the Stewartstown Historical Society, Stewartstown, Pennsylvania.*

A couple days later, a neighbor discovered Rehmeyers's body. The shocking nature of the crime scene shook the community, but it was nothing compared to the story that soon emerged. Alice Rehmeyer informed police about Blymire and Curry's visit, and they soon zeroed in on their suspects. As details emerged, newspapers around the country covered the unfolding story of the "York Witchcraft Murder" with great interest. Every bizarre detail of Blymire's magical and cursed world was described for the curious public. When the men went to trial, there were daily reports of the proceedings. Blymire and Curry ended up receiving life sentences, and Hess received ten years. Blymire and Curry would eventually be paroled and live rather uneventful lives. Curry, the youngest, even served during World War II and became a talented artist.

The extent of the impact of the York Hex Murder has been debated. Though authorities in York did not launch any official assault on the persistent folk beliefs, the press, experts and authorities in other parts of the state eventually would. At the very least, the murder and trial caused others to pay attention, and sometimes they found hexes when there was nothing there.

The Hex Panic

The sensationalist media coverage of the York Hex Murder trial brought intense scrutiny to the folk practices of the Pennsylvania Germans. Quick to label the practices a form of witchcraft, the press maligned all practitioners of powwow, even if they were only providing healing services. Lurid descriptions of magic and strange beliefs filled the newspapers and shocked Americans who were otherwise unaware that such traditions had continued into the twentieth century. In a foreshadowing of the Satanic Panic of the 1980s (discussed in part five), law enforcement officials, doctors and educators united in an effort to put an end to what they viewed as a superstitious and dangerous practice. Some law enforcement and government

Trials of Hex, written by J. Ross McGinnis in 2000, is the definitive account of the murder of Nelson Rehmeyer and the subsequent trial. *Courtesy of J. Ross McGinnis.*

officials were quick to attribute a supernatural motivation to any strange new cases that they encountered. During the trial, York County Coroner L.V. Zach claimed that the deaths of five children in the previous two years could be attributed to powwowers. He stated that the children's parents took them to folk healers when they became ill instead of real doctors, and as a result, they died. There had been no formal investigations, however, and he stated only that the cases were a matter of common knowledge. The *New York Times* discussed the coroner's statements under the dramatic headline "Death of 5 Babies Laid to Witch Cult." The *Times* article also quoted unnamed officials of the York County Medical Society, who stated that the coroner's count of deaths attributed to witchcraft was much too low.

In such a context, any death that was even vaguely connected to a powwower or that was even perceived to have a connection was labeled a hex murder. One such case occurred in March of 1929 when the body of twenty-one-year-old Verna Delp was discovered in the woods at Catasauqua, near Allentown. On her body were three pieces of paper with magical charms written on them, supposedly to protect from murder and theft. A coroner's report identified three poisons in her body, and it appeared that she had taken them voluntarily. The young woman's adoptive father, August Derhammer, revealed to police that he had recently discovered that his daughter had been receiving treatments from a powwower and that she had been planning to visit him again the day after she died. The powwower was identified as twenty-nine-year-old Charles T. Belles. Police were sure that they had another hex murder on their hands, and Belles was arrested. Belles initially denied treating Delp but later admitted that he was treating her for eczema. He claimed only to be a faith healer, not a hex doctor. The authorities did not believe him, and though they could find no direct evidence to link him to the crime, they continued to hold him in jail. Upon further investigation, it was discovered that Delp was pregnant and that she had not seen her boyfriend, a truck driver named Masters, for several months. She had not yet told her family of the situation and was possibly looking to end the pregnancy. Even though this new information had come to light, police still insisted that Belles must still be partially responsible. The obsession with hexes and powwow distracted the authorities from examining other possibilities, including a botched abortion attempt, suicide or murder at the hands of someone other than Belles. By April, they still had no substantial evidence with which they could charge Belles with murder, but they charged him anyway. Finally, Belles received a hearing in mid-April after filing a writ of habeas corpus. He was released on $10,000 bail, and the charges of murder were eventually dropped.

The press laid another death at the feet of powwowers in early January 1930. The *New York Times* ran a headline that read "Hex Treatment Seen in Death of Woman." Mrs. Harry McDonald, a thirty-four-year-old housewife from Reading, died after receiving severe burns in her home. She had apparently been given some kind of lotion or ointment from a hex doctor that was rubbed on her skin. At some point during the night she had caught fire when getting too near her stove. She was severely burned, and when her husband, who worked the night shift, found her in the morning, she was on the verge of death and could not be saved. The woman's brother told the press that he believed the lotion that she was wearing was too flammable and caught fire, ending his sister's life. He cited no evidence for this, but the press latched on to that aspect of the tragedy.

Urban Philadelphia was not immune to the hex panic either. Early on January 20, 1932, the body of Norman Bechtel was discovered in Germantown under a cherry tree on a temporarily vacant estate. Only thirty-one years old, the accountant and Mennonite Church worker had nine stab wounds in and around his heart. Some of the wounds appeared to be in a circle, and they had pierced not only his suit and overcoat, but also his eyeglass case. Investigators also found mysterious cuts on Bechtel's face. A crescent shaped cut was made on each side of his forehead, and a vertical cut ran from his hairline to his nose. Two additional cuts ran off the vertical slash and in the direction of the crescent shaped cuts. Bechtel's valuables had been taken, and his black car was discovered six miles away in west Philadelphia. From the bloodstains in the automobile, it was clear that Bechtel had known his attacker well enough to let him or her into his car. Though such a case might normally have looked like a robbery gone bad, detectives thought that the strange cuts on the victim's face might have special occult significance. Bechtel had grown up in the farming country around Boyertown where the practice of powwow had once been common. They immediately began a search to find any possible evidence of a new hex murder. Captain Harry Heanly, the chief investigating officer, had the victim's apartment thoroughly searched for any possible connection. They found no signs of folk magic, only Mennonite books and pamphlets. After following a few more leads, the police still had no answers, and the media began to refer to the case as a hex murder. The case remained unsolved until April 1937, when thirty-six-year-old William Jordan confessed that he and four others had killed Bechtel, whom they had been attempting to blackmail. Most of the details of Jordan's confession were not publically released, as Bechtel had been involved in "several love affairs" and had a large life insurance policy.

If the pseudo–hex crimes had been the only ones, it is likely that the scare would have died out sooner as the public lost interest. That was not to be the case, and another actual hex murder sealed the fate of folk magic in the state for the coming decades. The second hex murder occurred in Pottsville, Schuylkill County, in 1934.

THE SHINSKY CASE

A gunshot shattered the tranquility of the home of Mrs. Susan Mummey around 8:00 p.m. on Saturday, March 17, 1934. The blast of a shotgun tore through the living room window and struck the sixty-three-year-old (or fifty-nine, depending

Albert Shinsky, depicted here while waiting for trial, killed Susan Mummey in 1934 to break the hex that he believed that she had placed on him. *Author's collection.*

on the source) widow while she stood next to her adopted daughter. Mummey was attending to the injured foot of her boarder, Jacob Rice, who was seated in front of her. The oil lamp that her daughter was holding shattered as the shell passed through the room. Mummey was killed, and the other two took cover, not knowing if there would be more shots. The two waited all night in fear, thinking an assassin lurked outside of the house waiting to pick them off. As morning approached, Rice decided to make the two-and-a-half-mile trip to Ringtown to report the crime.

Initially, police thought that the murder was the result of nothing more than a backwoods feud that turned violent. But soon the case took a bizarre turn when twenty-four-year-old Albert Shinsky confessed to the killing. He claimed that the murder was actually self-defense and that Mummey had placed a hex on him seven years earlier when he was working in a field across from the Mummey farm. There had been disputes about the property, and one day Mrs. Mummey walked to the fence and stared at him intently for a long time. Shinsky claimed that he felt a cold perspiration come over him, and his arms went limp. From that point on, he was unable to work. It was only the beginning of his alleged torment.

Shinsky claimed that whenever he saw a sharp object, it would morph into a large black cat with flaming eyes from which he could not look away. The cat would also sometimes appear to him at night while he was in bed. It would slowly creep across his room and crawl up onto his bed. The appearance of the cat would also make him incredibly cold, so much that he had to get up and run around his room to get warm again. Shinsky sought the help of several powwowers to deal with the hex. One advised him to recite the phrase "God the Father, God the Son, God the Holy Ghost"

every time he saw the cat. The recitation usually made the cat disappear if he could overcome his terror and say it. Though his family thought that he was exaggerating and was just too lazy to work, Shinsky seemed to genuinely believe that he was hexed. Eventually, he could no longer endure the supernatural harassment, and he killed Mummey. He told police that the minute she died, he felt that the curse was lifted.

Prosecutors wanted to give Shinsky the death penalty for the killing, and the press once again emphasized the danger of the strange beliefs. Several psychiatrists had different ideas, however. Though the police were thoroughly convinced that Shinsky was sane, a commission of doctors determined that he was insane. Shinsky was sent to Fairview State Hospital. He remained in mental institutions for most of the rest of his life. The case seemed to confirm in the public eye that the belief in witchcraft was still a real threat. Action needed to be taken to prevent further incidents.

THE FATE OF FOLK MAGIC IN PENNSYLVANIA

While practitioners of powwow had a few defenders and retained plenty of clients, the tide of public opinion had turned definitively against them. One of the voices that defended the folk beliefs was Monroe Aurand Jr., known for his colorful pamphlets on the Pennsylvania Germans. Aurand felt that the German population of the state was being unfairly stereotyped, because supernatural folk beliefs existed among all segments of society and ethnic groups. His pamphlets included the 1942 publication *The Realness of Witchcraft in America*. Though meant as a defense, his writings were sometimes misinterpreted as a confirmation that the belief in witchcraft was still widespread enough to be a problem.

As a result of the two high-profile murder cases and the other suspected cases, Pennsylvania's school system declared war on the belief in hexes, especially in the rural areas in which it seemed most prevalent. It was hoped that within several years, focused instruction and renewed emphasis on science would erase the superstition that seemed to plague the countryside. State authorities also launched a campaign against powwowers and hex doctors directly, arresting and prosecuting them for practicing medicine without a license. Combined with the relentless media sensationalism, the three-pronged assault on Pennsylvania folk magic drove many of the remaining powwowers underground. Except for a few who retained public storefronts,

most of those who continued to practice actively avoided the public spotlight and downplayed their work to any non-believer. They continued to provide services, however, for those who sought them out. As time went on, fewer of the younger generations showed interest in learning the old methods of healing and hex. Still, the practice did not die out and has in recent years made something of a comeback as interest in New Age ideas and the supernatural has again proliferated. Dr. David Kriebel documented some of these contemporary folk healers in *Powwowing Among the Pennsylvania Dutch*. Though none of these modern healers practices any kind of witchcraft, they demonstrate that many of the German magical beliefs are alive and well in the modern world.

Before we leave the subject of the hex murders, there is one final case to mention. Another hex murder, similar to the Shinsky case, occurred in 1939. It was not as widely publicized as the others, perhaps because the public had become used to the perceived dangers of the belief in witchcraft, and the case seemed to again confirm those beliefs. A twenty-two-year-old farmhand from the Easton area named Howard A. Romig shot and killed twenty-four-year-old Dorothy Buskirk and her sixteen-month-old daughter. Though psychiatrists testified that he was driven to kill the woman because he believed that she had hexed him, it was not enough to have him declared insane. A jury found him guilty of first-degree murder and sentenced him to life in prison.

The outbreak of World War II and other pressing concerns eventually caused the coverage of "hex"-related crimes to fall off. The America that emerged after the war was very different than the one that had entered it. The rise of a mass culture began to blur regional differences. American consumerism came to be guided by the growing youth culture, and young people had free time and mobility that they did not have before. The witches that were tied to the ethnic cultures of their parents seemed distant as they ventured out in cars from their new suburban homes. Though traditional witchcraft continued to exist in many areas, for the young people of modern Pennsylvania, the witch had entered the realm of urban legend.

The Witch in Urban Legend

While the belief in witchcraft is still not extinct in the modern world, it is certainly by no means as widespread as it once was. In the second half of the twentieth century, witches continued to exist in Pennsylvania's folklore, but in a different form. Witches and witchcraft became linked more often with urban legends than with folk magic. Urban legends are one of the most popular forms of folklore in America today. Often referred to as contemporary legends by professional folklorists, these legends pass from one person to another by word of mouth and through the Internet. They have a feeling of authenticity because they are often heard from trusted individuals and friends, who purportedly hear them from other trusted friends and sources. Such legends often carry a warning about some type of danger in everyday life, something that is not heard on the news or from official sources. At first examination, these legends seem to be legitimate, because they are set against the familiar backdrop of daily life and a local setting. When one takes a closer look, they usually discover that the facts do not add up, and they are full of distortions or outright fabrications. Even though they appear to be set in a specific local place, they actually bear a close resemblance to similar legends all around the country. The source of the legend, the friend of a friend who originally passed it on, can almost never be traced.

While urban legends are not true in the factual sense, they are "true" in the fact that they represent the fears of society and tensions about our daily lives. New legends emerge every decade reflecting the newly perceived threats

of those years. Folklorists have documented hundreds of these legends and tracked their changes over time. For our purposes, the origins of modern urban legends about witches can be placed within fears that emerged in the 1970s and 1980s. Several factors converged during those decades that allowed such legends to proliferate. Beginning in the 1970s, for a variety of reasons that extend beyond the scope of this book, the media and society in general began to perceive an increased amount of threats toward children. This manifested itself in a variety of ways, one example being the poisoned candy scare that surfaced every Halloween. There was also much more media attention paid to serial killers and child abductions. (For a full explanation of this phenomena, see Philip Jenkins's book *Decade of Nightmares*.) Another factor that would influence the legends was a renewed and increased interest in the supernatural, the paranormal and the occult in segments of society from the seventies onward. Such an interest is easily traceable in popular culture, and it influenced those who grew up during that time. Both of these factors combined to fuel the "Satanic Panic" of the 1980s.

The Satanic Panic and satanic ritual abuse scare lasted from the early 1980s into the 1990s. The panic would provide a new context for legends involving witches and link them more directly to explicitly satanic activity. It began after a handful of psychologists and law enforcement officials used now discredited techniques to "recover" memories of satanic abuse among children in daycare centers in California. Though the memories were completely false, it sparked a national scare that disrupted or ruined the lives of many people. The media latched on to the story and fed the hysteria, claiming that there may be thousands or even millions of Satanists in a secret network around the country, abducting, abusing and sacrificing children. Anything vaguely connected to the occult could cause suspicion of involvement. Music, games and even large corporations were accused of having hidden satanic messages. The fact that many law enforcement officials throughout the country took the accusations seriously seemed to lend credence to them. As a result, fears of Satanism left their imprint on the urban legends of those years, especially the supernaturally themed ones. While satanic cults appeared most frequently in the urban legends, abducting and sacrificing children and teenagers, witches and witches' covens were also common.

Since specific witches were not identified in the panic, many of the legends revolved around places that were linked to them in some way. As a result, most urban legends about witches became legend trip destinations. A legend trip is an interactive type of urban legend, where a group of people, most often teenagers or young adults, travel to a secluded but still car-

accessible location that is associated with some type of supernatural activity. Sometimes some type of ritual action is required at these sites to provoke interaction with the supernatural (flashing headlights three times, blowing the car horn, repeating a phrase, etc.) By triggering a supernatural response, or at least scaring themselves, the participants in a legend trip become part of the legend themselves while testing societal and personal boundaries.

Legend trip destinations involving witches are most likely to fall into two categories, although there are certainly exceptions to this rule. There are many urban legends about witches associated with cemeteries and alleged burial sites. Graveyards and cemeteries are often associated with the supernatural and are common legend trip sites. The other category of witch-infested legend trip destinations is the "witch house." A witch house is usually a run-down or abandoned structure that has become associated with rumors of witchcraft. This type of legend proliferated during the Satanic Panic and was often associated with the abduction and sacrifice of children on the premises. Now we will take a closer look at these urban legends, starting with the alleged witch Mary Black.

Mary Black's Grave and Cemetery Witches

A popular urban legend in Lawrence County centers around one of the area's oldest burial grounds. Tindall Cemetery, near Turkey Hill in Shenango Township, has long been believed to be the burial site of a witch. According to the legend, Mary Black, who died in 1888, was known to be a witch in her lifetime, and her gravestone became the destination for hundreds of teenagers engaged in legend trips over the years. One common form of the legend claims that if one journeys to the grave site and calls her name three times, the witch will reemerge that night (either immediately or after you go to sleep) and claw your face. It resembles the traditional urban legend of Bloody Mary, except with a tombstone instead of a mirror. Other accounts have claimed that the hand of the witch emerges from the ground and claws at the legs of the late-night visitors. In some of the earliest versions of the legend, Mary Black visited those who called her name in the form of a black cat, scratching them and tormenting them in other ways.

The legend was popular for so long that multiple generations have made the late-night trip to the cemetery. By the 1970s and 1980s, some people claimed to see cult members visiting the grave, wearing black robes and

For decades, legend-trippers sought out the grave of alleged witch Mary Black in Tindall Cemetery, hoping to trigger some type of interaction with her ghost. Stories of the supernatural were attached to Black decades after her death, but she was never actually believed to have been a witch while she was alive. Today, because of changes in the terrain, the cemetery site is flooded and not easily accessible, as seen in this photograph. *Courtesy of Janice Ferrainolo.*

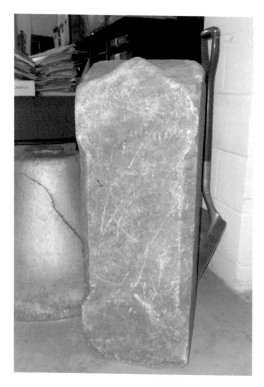

The gravestone of legendary "witch" Mary Black, now housed at the Lawrence County Historical Society. *Courtesy of Michael Hassett.*

chanting. Such associations increased during the years of the Satanic Panic. The cemetery received so many visits from legend trippers that vandalism became a severe problem, and by the 1990s, Mary Black's tombstone had been knocked over and moved several times. Someone even attempted to dig up her body. Finally, the tombstone was given to the Lawrence County Historical Society to prevent further damage. The absence of the stone has failed to halt the late-night visits of legend trippers, and they continue to wander in the dark searching for a marker that is no longer there.

Despite the popularity of the legend, the truth is that Mary Black was never considered to be a witch during her life and only became associated with witchcraft when a local storyteller assigned her name to another story of a witch. Harry "The Hermit" Stein was a colorful local character who told tales of Lawrence County's past. He originally told the tale of a witch named Lisa Sturner, who was usually accompanied by a magical black cat. As time went on, he and others substituted the name of Mary Black in the tales, perhaps because there was a physical remnant (her grave) to ground the story in reality. The story caught on and spread among young people, who could take their friends out to find the grave site.

Besides the grave of Mary Black, a multitude of other burial sites in Pennsylvania have become associated with witches since the 1970s. Here are a few examples:

- Across the state from Lawrence County, another grave of a witch named Mary allegedly exists in Shupp Cemetery in Luzerne County. According to this urban legend, a curse exists on the tombstone of this Larksville witch. If one goes to her grave site and reads it, a series of terrible events will plague them. Strange paranormal activity is supposed to be common at the cemetery. Stories of the witch and her curse have given the burial ground the nickname of "The Witch's Cemetery."

- Smalls Cemetery, near Cooperstown, Venango County, is rumored to be the burial site of an entire coven of witches. During the 1980s, satanic cults and modern covens supposedly used the secluded area to conduct their own occult rituals. The alleged activity attracted numerous legend trippers who sought out the witches' graves and has unfortunately led to vandalism of the old and historic gravestones.

- Georgetown Cemetery in Beaver County has its own interesting witch legend. In the 1800s, a woman who practiced witchcraft was allegedly seized by her neighbors and hanged from a tree in the cemetery. When they let her fall, the tree limb broke, and the witch managed to

escape. It is said that if you visit the cemetery on Halloween, you will see the witch return to the site of her near-execution.

- St. James Episcopal Cemetery in Bristol, Bucks County, is home to the famous "Witch's Chair." The otherwise unassuming metal chair sits atop the grave of Merritt Wright, who died in 1911. It was placed at the grave for when his wife came to visit, but over the years, the seemingly out-of-place chair has spawned an urban legend. If one sits in the chair at midnight during October, they can feel the arms of a witch wrap around them. The origin of the legend is unclear, though it is common for unusual grave sites to have legends associated with them.

- Titusville, Crawford County, has three witches' graves located in Woodlawn Cemetery. All three of the stones lay flat on the ground next to each other, though they are of the type that would normally stand upright. One of the stones has a face carved into it that allegedly bleeds at certain times (under the full moon, near Halloween, etc.) The alleged witch buried in that grave is commonly referred to as the "bloody witch." Like the other witch graves, it is not clear exactly what inspired the legend, but it remains a popular legend trip site.

- Near Perryopolis, Fayette County, is the Providence Meeting House and graveyard, often known to locals as the Quaker Church. The property was used by the local Quaker community in the 1800s and in the twentieth century has become associated with a variety of ghost stories and local legends. One of these legends, which circulated during the 1980s and 1990s, asserted that during the mid-1800s, the local Quakers tried, convicted and executed a witch on the property. Her ghost is said to become aggressive when intruders venture onto the property at night, pushing them around and knocking them to the ground. The site was also allegedly used as a meeting place by satanic cults during those years.

- Crum Cemetery in Windber, Somerset County, reputedly contains the grave of the witch Rebecca Crum. Rebecca became the target of her neighbors' wrath after they discovered she was practicing witchcraft. An angry mob hanged or burned her in the cemetery, depending on which version of the story you hear. Her ghost can be seen in the cemetery wandering near the graves, hungry for vengeance. During the 1980s and 1990s, satanic cults and a coven of witches frequently used the burial ground for dark ceremonies.

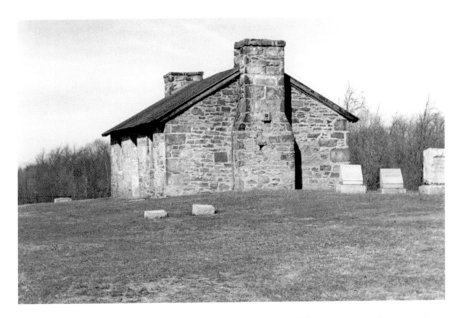

Urban legend claims that a witch was killed at the "haunted" Quaker meetinghouse and graveyard near Perryopolis, Fayette County, in the 1800s. *Courtesy of Tony Lavorgne.*

Another view of the Quaker graveyard near Perryopolis. *Courtesy of Tony Lavorgne.*

All of these legends, and numerous others around the state, demonstrate the widespread connection between graveyards and witches in popular contemporary legends. Even though none of these legends are historically accurate, these stories at least show the willingness to temporarily suspend disbelief in witchcraft for the sake of supernatural adventure in the form of the legend trip. Witch houses, which are almost as common in modern lore, serve a similar folkloric function.

WITCH HOUSES AND COVENS IN THE WOODS

Abandoned and isolated structures often inspire tales of the supernatural. During the Satanic Panic, such spooky locations became the center of tales about witches and cults in addition to the traditional ghost stories that one would expect. One such house is located in Exton in Chester County. The once abandoned structure, which has been renovated in recent years, was known locally as the "Witches' House" or "Witches' Graveyard." The large house sat empty for years, and several gravestones laid flat in the yard. The stones supposedly marked the burial sites of the first coven that used the house decades before. The witches were killed by angry neighbors and buried upright so they could not escape the grave by digging straight out. Since that time, other covens have allegedly used the house, sometimes abducting small children to use in their rituals. A nearby shed was rumored to conceal a tunnel leading to the main house. It was meant to serve as an escape route for the witches. (While the shed does conceal a deep stone chamber, it was filled with water for many years, making it impossible to determine if there really was a tunnel.) For years, teenagers made the journey to the house looking for signs of the supernatural and leaving graffiti behind. Since the renovation, the allure of the house and its inherent spookiness has faded.

In Lawrence County, to the west of New Castle once stood an abandoned house that the local youth referred to as the Blood House. According to this legend, a witch who lived in the house abducted local children and sacrificed them to the Devil. She buried their bodies in the unkempt fields around the house. If someone lingers at the property for too long, it is said that the witch will attempt to possess them. The ghosts of the witch's victims also appear at the site. If legend trippers drive to the house and put their car in neutral, the ghosts of the children will push it away from the house. The Blood House burned down a little over a decade ago, but the ruins continued to attract visitors on nightly

legend trips. Of course, there were not actually dozens of missing children in the area, but the story fit firmly within the fears of satanic ritual abuse.

Outside of Dallas, in Luzerne County, was another witch house near the property of a Jewish community center summer camp. Campers were warned not to go near the abandoned one-room house that sat near a gravel road in the woods. A coven of witches was rumored to meet in the house to make potions. The witches also used their magic to summon the ghosts of campers and other people who died near the old house to haunt the property. The legend was popular until the collapse of the small structure in the early 2000s. Unlike the usual societal fears that inspire these legends, the camp counselors may have had a very legitimate reason for spreading the story: a bear was believed to have been living in a cave very close to the house.

Even though urban legends usually have little basis in fact, sometimes they attach themselves to the sites of actual tragedies or, in this case, confirmed sites of witchcraft. Such is true for the home of Nelson Rehmeyer. Because of the famous murder, the old house in Rehmeyer's Hollow, or Hex Hollow as it is now often called, became the center of many urban legends. The youth of the late twentieth century may not always have been familiar with the details of the famous case, but they certainly knew that the house was associated with witchcraft and murder. Aside from the true story, which is frequently retold around Halloween, the house became associated with witches covens, satanic cults and many other variations of common legends. Folklorist David J. Puglia compiled the most comprehensive list of such contemporary legends associated with the site, collecting almost forty different versions. They can be found in his engrossing collection of regional folklore, *South Central Pennsylvania Legends and Lore.*

The home of Nelson Rehmeyer continues to inspire modern urban legends about witches, Satanists and ghosts. *Courtesy of Sean Coxen.*

While old graveyards and vacant houses became home to many of the witches of urban legend, there were other isolated locations that came to be associated with their imagined activities. In the northern part of Allegheny County, at the edge of North Park, is a road that has been linked with the supernatural for decades. Irwin Road, known to legend trippers as Blue Mist Road, has been home to ghosts, monsters, the Ku Klux Klan, satanic cults and witches' covens. The relatively isolated nature of the mostly closed road makes it the perfect location for a legend trip. While there have been various types of supernatural activity reported there, satanic cults and witches covens were associated with the crumbling and abandoned stretch of road during the 1980s and 1990s. Tales of sacrificed animals and missing teenage virgins circulated widely among the youth in the townships around the park. There were even rumors of a witch house or a cult house along the road, but no standing structure is actually present along the closed portion of the road, although there is a lone mailbox.

Like the legend of Blue Mist Road is that of the Witches' Triangle (also known as the Devil's Triangle) in Berwick, Columbia County. The small

Irwin Road, often known as Blue Mist Road, was rumored to be the home of witches' covens and evil cults during the Satanism scare of the 1980s and early 1990s. *Author's collection.*

patch of woods that makes up the triangle is located close to a golf course. One version of this legend claims that three young witches were captured there by local farmers while engaged in a ritual in the 1800s. The trio of witches was hanged from the trees, and since that time, the area has been cursed. It has reportedly been used by the Ku Klux Klan, satanic cults and, of course, covens of witches. A nearby abandoned house was said to be the site of a gruesome murder-suicide in which a man slaughtered his family. The implication is that the evil of the Witches' Triangle drove him to commit the crime. Of course, there is no evidence that any of these events actually happened, but it has not stopped the parade of legend trippers who have come over the years to interact with the supernatural.

Like the two previously mentioned locations, there are dozens of other haunted roads and wooded areas around the state with similar stories attached to them. Sites linked to historical witchcraft, like Hexenkopf Hill and the Witches Hill, gathered legends much like Nelson Rehmeyer's house. In many ways, the era of the Internet has made these witch stories more popular and accessible to new generations. The witches of Pennsylvania folklore will continue to live on in a variety of forms in the future.

Why Witches Won't Go

This survey has only skimmed the surface of the complex systems of belief in witchcraft, folk healing and folk magic that have long existed in Pennsylvania. Many groups brought traditions similar to the German and English settlers. African Americans held on to their trust in the folk-magical system of hoodoo well into the twentieth century. In urban industrial areas and rural coalfields, Southern and Eastern European immigrants brought their belief in the evil eye and systems of folk magic that were very similar to their Central European counterparts. Though the belief in witches has become entwined in urban legends in recent times, the traditional ideas about witchcraft have not disappeared. In fact, in recent years, there has been a resurgence in the practice of powwow. For some believers, it is combined with other esoteric or New Age systems of magical belief. For others, they attempt to remain true to the Pennsylvania German traditions. This is evidenced by the recent publication of two new grimoires of traditional Pennsylvania powwow practices. Karl Herr's *Hex and Spellwork: The Magical Practices of the Pennsylvania Dutch*, published in 2002, serves as an introduction to some of the meaning and mechanics of folk magic as used by modern practitioners. The most thorough modern account written by a practitioner of both the historical background and current practice of powwow is *The Red Church, or The Art of Pennsylvania German Braucherei*, by C.R. Bilardi. The hefty and encyclopedic volume was published in 2009. It seems that the once-obscure practice is now experiencing a minor renaissance.

Conclusion

But why does the belief in witchcraft and magic survive in Pennsylvania and in the modern world? It survives precisely because it is not modern. It is old and esoteric and involves forces that cannot be measured by our rational scientific world. The belief in witchcraft and the supernatural in general is one of the ways in which people, usually unknowingly, push back against the dehumanizing nature of our technological and bureaucratic world. Traditional witchcraft, though associated with supernatural evil, implicitly means that there is also supernatural good. By extension, witchcraft confirms the belief that there are forces more powerful than the material world in which we all live. For that reason, the belief in witchcraft will never be entirely extinguished.

Selected Bibliography

Archival Materials

AlNajada, Bonnie. "The True Story About Mary Black, So-Called Witch." Unpublished manuscript. Lawrence County Historical Society.

Blue Mist Road Interviews. Series of transcribed interviews conducted in North Park, Allegheny County, by Emily Jack. July and August 2004.

George Swetnam Papers, 1999.0039. Library and Archives Division, Senator John Heinz Pittsburgh Regional History Center.

Gerstein, Rachael. Interview with author about Luzerne County Witch House, February 2013.

McGinnis, J. Ross. Telephone conversation with author, April 2013.

O'Neil, Gerard F. "The Mess is the Message: The Legend of Mary Black's Grave in Lawrence County Pennsylvania." Unpublished manuscript, 2012.

Articles

Adams Sentinel. "Witchcraft in Berks." July 15, 1862.

Altoona Mirror. "Suspect Arrested in Another Hex Murder." March 18, 1929.

Arnold, J.O. "Superstitions Ingrained in Minds of Many Moderns." *Connellsville Daily Courier*, July 28, 1947.

Atlanta Constitution. "Convicted of Witchcraft." September 21, 1902.

Baker, Leone. "Witch Doctors Still Prey on Superstitious." *New York Times*, December 23, 1928.

Bedford Gazette. "Pardon Board Asked to Commute Life Term in Hex Murder." June 18, 1952.

Bird, S. Elizabeth. "Playing with Fear: Interpreting the Adolescent Legend Trip." *Western Folklore* 53, no. 3 (1994): 191–209.

Black, Esther. "Lawrence County Legends." *Keystone Folklore Quarterly* 7, no.1 (1962): 37–40.

Blecourt, William de. "Witch Doctors, Soothsayers and Priests: On Cunning Folk in European Historiography and Tradition." *Social History* 19, no. 3 (1994): 285–303.

Byington, Robert. "Powwowing in Pennsylvania." *Keystone Folklore Quarterly* 9, no. 3 (1964): 111–117.

Chester Times. "Believed in Witches: A Woman's Remarkable Faith in the Black Art." June 6, 1885.

———. "Hex Murder Case Will Be Revived." February 18, 1936.

Connellsville Herald. "Somerset County Superstition." February 23, 1883.

Connellsville Keystone Courier. "Some Superstitions that Frighten Foolish People." February 29, 1886.

Conner, Erinn. "Lecture Explores 'Supernatural' Past of Pennsylvania Dutch." *Reading Eagle*, August 8, 2011.

Davies, Lawrence E. "Hexing Is Firmly Rooted." *New York Times*, March 3, 1935.

Davies, Owen. "The Nightmare Experience, Sleep Paralysis, and Witchcraft Accusations." *Folklore* 114, no. 2 (2003): 181–203.

Devlin, Ron. "Early Pike Township Folk Healer Remembered." *Reading Eagle*, November 9, 2009.

Ellis, Bill. "Kurt E. Koch and the 'Civitas Diaboli': Germanic Folk Healing as Satanic Ritual Abuse of Children." *Western Folklore* 54, no. 2 (1995): 77–94.

Ensminger, Robert. "Hex Signs and Barn Stars in Pennsylvania: Finding the Missing Link." *Material Culture* 36, no. 2 (2004): 8–21.

Fooks, David. "The History of Pennsylvania's Barn Stars and Hex Signs." *Material Culture* 36, no. 2 (2004): 1–7.

Frassinelli, Mike. "Is Hexenkopf Not Just a Rock?" *Morning Call*, October 31, 1999.

Frazier, Paul. "Some Lore of Hexing and Powwowing." *Midwest Folklore* 2, no. 2 (1952): 101–107.

Gettysburg Star. "Witchcraft in Pennsylvania." March 4, 1853.

Gettysburg Star and Sentinel. "John Curry, York Hex Slayer, Asks Freedom." June 23, 1934.

Gipson, Phyllis. "Haunted Tindall Cemetery Suffers Litter, Trash." *Lawrence County Scene*, May 21–22, 1977.

Gorman, Herbert. "Once It Was Reasonable to Believe in Witchcraft." *New York Times*, March 17, 1929.

Holly, Donald H., Jr., and Casey E. Cordy. "What's In a Coin? Reading the Material Culture of Legend Tripping and Other Activities." *Journal of American Folklore* 120 (2007): 335–354.

Hruska, Judy. "Halloween Haunt: Mary Black's Legend Refuses to Die for County's Youth." *New Castle News*, October 30, 2004.

Huntingdon Daily News. "Pow-wow Doctor to Get Habeas Corpus Hearing." April 4, 1929.

Indiana Evening Gazette. "Another Pennsylvania Hex Murder Seen with Finding of Weird Symbol of Voodooism." January 21, 1932.

———. "Powwow Doctor Freed Under Bail." April 15, 1929.

Kennedy, Joseph. "Before Salem, a Witch Inquiry in Pennsylvania." *Philadelphia Inquirer,* August 1, 2004.

Kline, Dave. "The Hills are Alive with Restless Spirits." *Berks Country*, October 31, 2012.

Lancaster Daily Gazette. "Powwow Man's Patient Dead, Hex Murder." March 18, 1929.

Landman, W.R. "The Other Side of Local History: Witches and Witch Killers." *Milepost,* July 1995.

Lehigh Register. "Witchcraft in Pennsylvania." March 2, 1853.

Litowitz, Pat. "Legends." *New Castle News,* October 29, 2007.

Lowell Sun. "Hex Murder Is Solved." April 15, 1937.

Mahr, August C. "Origin and Significance of Pennsylvania Dutch Barn Symbols." *Ohio Archaeological and Historical Quarterly* 54 (1945): 1–32.

Mappen, Marc. "The Trial Of Witches in Mt. Holly." *New York Times*, October 28, 1984.

Mathias, Madeleine. "Legends of Hexenkopf Live On." *Philadelphia Inquirer*, February 25, 1987.

Milwaukee Daily Journal. "Two Weird Stories: People in Pennsylvania Said to Believe in Witches." February 15, 1889.

Mountain Democrat. "The Mountain Hunter." October 25, 1879.

New Castle News. "Grill Youth in Death of Girl." March 19, 1929.

New York Times. "Another Pennsylvania Story." January 31, 1878.

———. "Bars Witchcraft as Murder Defense." January 9, 1929.

———. "Boy Denies Joining in Witch Killing." January 11, 1929.

———. "Charm Book Throws Light on Witch Trial." January 6, 1929.

———. "Consulting the Witch." April 19, 1885.

———. "Convicted of Witchcraft." September 12, 1902.

———. "A Couple Charged with Being Witch Doctors." July 8, 1902.

———. "Death of 5 Babies Laid to Witch Cult." December 4, 1928.

———. "A Famous Witch Woman." November 2, 1888.

———. "Fear of Witchcraft Leads to Murder." December 1, 1928.

———. "For Sanity Test in Hex Case." March 30, 1934.

———. "For the Pennsylvania Dutch, a Long Tradition Fades." July 22, 2006.

———. "Hex Is Being Driven Out by Pennsylvania Schools." October 20, 1936.

———. "Hex Slayer Gets Life." April 16, 1939.

———. "Hex Slayer Insane, Psychiatrist Holds." March 27, 1934.

———. "Hex Treatment Seen in Death of Woman." January 7, 1930.

———. "Hill Hawks Still Believe in Witchcraft." June 24, 1923.

———. "Hints Federal Action on Witch Murder." December 10, 1928.

———. "Poisons Killed Girl Discovered in Wood." March 18, 1929.

———. "Powwow Doctors Use Faith And Prayer." December 9, 1928.

———. "Slain Girl Wore Hex Murder Charm." March 19, 1929.

———. "Slayer Cuts Signs on Victim's Head." January 21, 1932.

———. "Superstition in Pennsylvania." July 24, 1880.

———. "Third Witch Killer Convicted at York." January 13, 1929.

———. "Two Are Held for Trial in War on Hex Doctors." September 16, 1933.

———. "Where Hex Is a Force." June 15, 1941.

———. "Where Witches Flourish in This Twentieth Century." September 10, 1911.

———. "Witchcraft Trio Face Trial Today." January 7, 1929.

———. "Witches and Witchcraft." April 6, 1885.

———. "Woman in Witchcraft Case." September 11, 1902.

———. "Woman Seeks Hex Healer." June 21, 1936.

The North American. "Reading Man Seeks Law's Protection for his Son, Who Is Hexed By Lazarus, a Man Who, at Will, Can Change Himself into a Cat or Dog." July 18, 1899.

———. "Witchcraft at Reading." February 16, 1894.

Pennsylvania Inquirer and Daily Courier. "A Trial for Witchcraft in Pennsylvania." June 11, 1838.

Pinkowski, Edward. "Jack O' Lantern's Children." *Keystone Folklore Quarterly* 3, no. 1 (1958): 10–13.

Pittsburg Dispatch. "Witchcraft Reigns, Insanity and Disease Rampant in the Hills Near Reading." November 1, 1891.

Pottsville Republican. "Aged Woman of North Union Township Victim of Assassin's Bullet." March 19, 1934.

———. "Witch Lore Motive for killing." March 22, 1934.

Reading Eagle. "Held on Witchcraft Charge; District Attorney Orders Trial." June 9, 1929.

Reimensnyder, Barbara. "Legends About Witches in the Buffalo Valley." *Keystone Folklore Quarterly* New Series 3, no. 1 (1984): 34–50.

Rhone, George. "The Swamp Angel." *Keystone Folklore Quarterly* 10, no. 2 (1965): 86–91.

———. "Two North Pennsylvania Tales." *Keystone Folklore Quarterly* 8, no. 3 (1963): 122–128.

Rice, Diana. "Still the Witching Hour." *New York Times*, December 9, 1923.

Rosenberger, Homer. "The Hex Doctor and the Witch of Farrandsville." *Keystone Folklore Quarterly* 3, no.2 (1958): 42–45.

———. "The Witch of Pine Station." *Keystone Folklore Quarterly* 4, no. 1&2 (1959): 121–26.

———. "The Witch of Werner's Mill." *Keystone Folklore Quarterly* 2, no. 4 (1957–1958): 104–8.

Sandusky Star Journal. "Hex Murder Victim Had $60,000 Insurance." January 22, 1932.

Scranton Tribune. "Witch Doctor Has Trouble." January 8, 1902.

Shenango Valley News. "A Modern Witch." April 28, 1882.

Somerset Herald. "Uncle Joe Writes About Witches." November 23, 1892.

Tinsley, M. Ferguson. "This Time, Zombie Land Tale is True." *Pittsburgh Post-Gazette*, October 31, 2003.

Titusville Herald. "Faith Healer Held in Death." March 23, 1929.

———. "Witchcraft in Titusville." November 10, 1871.

Tucker, Elizabeth. "Ghosts in Mirrors: Reflections of the Self." *Journal of American Folklore*, 118 (2005): 186–203.

Tyrone Daily Herald. "Negro Confesses Part in 1932 Hex Murder." April 15, 1937.

Weaver, Karol K. "She Knew All the Old Remedies: Medical Caregiving and Neighborhood Women of the Anthracite Coal Region of Pennsylvania." *Pennsylvania History* 71, no. 4 (2004): 421–44.

Winslow, David J. "Bishop E. Everett and Some Aspects of Occultism and Folk Religion in Negro Philadelphia *Keystone Folklore Quarterly* 14, no. 2 (1969): 59–80.

"Witches Graveyard." *Eerie PA* 1, no. 1 (2005): 59–62.

Wrenshall, Letitia Humphreys. "Incantations and Popular Healing in Maryland and Pennsylvania." *Journal of American Folklore* 15, no. 59 (1902): 268–274.

BOOKS

Adams, Charles J., III. *Ghost Stories of Berks County.* Reading, PA: Exeter House Books, 1982.

———. *Luzerne and Lackawanna Counties Ghosts Legends & Lore.* Reading, PA: Exeter House Books, 2007.

Albert, George Dallas, ed. *History of the County of Westmoreland Pennsylvania.* Philadelphia: L.H. Everts & Company, 1882.

Anderson, Jeffrey E. *Conjure in African American Society.* Baton Rouge: Louisiana State University Press, 2005.

Aurund, A. Monroe, Jr. *The Realness Of Witchcraft In America.* Harrisburg, PA: Aurand Press, 1942.

Bilardi, C.R. *The Red Church or The Art of Pennsylvania German Braucherei.* Sunland, CA: Pendraig Publishing, 2009.

Boyer, Dennis. *Once Upon a Hex: A Spiritual Ecology of the Pennsylvania Germans.* Oregon, WI: Badger Books, Inc., 2004.

Bradsby, H.C., ed. *History of Luzerne County Pennsylvania.* Chicago: S.B. Nelson & Company, 1893.

Bristow, Arch. *Old Time Tales of Warren County.* Meadville, PA: Tribune Publishing Co., 1932.

Burmester, Bill. *Legends of Lawrence County Vol. II.* Marceline, MO: New Castle News/D Books Publishing, 1993.

Cooper, George. *Poison Widows: A True Story of Witchcraft, Arsenic, and Murder.* New York: St. Martin's Press, 1999.

Davies, Owen. *Grimoires: A History of Magic Books.* Oxford: Oxford University Press, 2009.

Demos, John. *The Enemy Within: A Short History of Witch Hunting.* New York: Penguin Books, 2008.

Ellis, Bill. *Aliens, Ghosts and Cults: Legends We Live.* Jackson: University Press of Mississippi, 2001.

———. *Lucifer Ascending: The Occult in Folklore and Popular Culture*. Lexington: University Press of Kentucky, 2004.

———. *Raising the Devil: Satanism, New Religion, and the Media*. Lexington: University Press of Kentucky, 2000.

Fischer, David Hackett. *Albion's Seed: Four British Folkways in America*. Oxford: Oxford University Press, 1989.

Games, Alison. *Witchcraft in Early North America*. Lanham, MD: Rowman & Littlefield Publishers, Inc., 2010.

Godcharles, Frederic A. *Daily Stories of Pennsylvania*. Chicago: Hammond Press, 1924.

Hazzard-Donald, Katrina. *Mojo Workin': The Old African American Hoodoo System*. Chicago: University of Illinois Press, 2013.

Heindel, Ned D. *Hexenkopf: History, Healing and Hexerei*. Easton, PA: Northampton County Historical and Genealogical Society, 2009.

Herr, Karl. *Hex and Spellwork: The Magical Practices of the Pennsylvania Dutch*. Boston: Weiser Books, 2002.

Hohman, John George. *Pow Wows or, The Long Lost Friend*. Airville, PA: Yardbird Books, 1992.

Hufford, David. *The Terror That Comes In the Night: An Experience-Centered Study of Supernatural Assault Traditions*. Philadelphia: University of Pennsylvania Press, 1982.

Kriebal, David W. *Powwowing Among the Pennsylvania Dutch: A Traditional Medical Practice in the Modern World*. University Park: Pennsylvania State University Press, 2007.

Linn, John Blair, ed. *Annals of the Buffalo Valley Pennsylvania*. New Orleans: Polyanthos, 1975.

Long, Carolyn Morrow. *Spiritual Merchants: Religion, Magic, and Commerce*. Knoxville: University of Tennessee Press, 2001.

McGinnis, J. Ross. *Trials of Hex*. York, PA: Davis/Trinity Publishing Company, 2000.

Milnes, Gerald C. *Signs, Cures & Witchery: German Appalachian Folklore*. Knoxville: University of Tennessee Press, 2007.

Newton, J.H., ed. *History of Venango County Pennsylvania*. Columbus, OH: J.A. Caldwell, 1979.

Poole, W. Scott. *Monsters in America: Our Historical Obsession with the Hideous and the Haunting*. Waco, TX: Baylor University Press, 2011.

———. *Satan in America: The Devil We Know*. Lanham, MD: Rowman & Littlefield Publishers, Inc., 2009.

Puglia, David J. *South Central Pennsylvania Legends and Lore*. Charleston, SC: The History Press, 2012.

Shaner, Richard H. *Hexerei: A Practice of Witchcraft Among the Pennsylvania Dutch*. Indiana, PA: A.G. Halldin, 1973.

Shoemaker, Alfred L. *Hex, No!* Lancaster, PA: Pennsylvania Dutch Folklore Center, 1953.

Smith, George. *History of Delaware County, Pennsylvania*. Philadelphia: Henry B. Ashmead, 1862.

Swetnam, George. *Devils, Ghosts, and Witches: Occult Folklore of the Upper Ohio Valley*. Greensburg, PA: McDonald/Sward Publishing, 1988.

————. *Pittsylvania Country*. New York: Duell, Sloan & Pearce, 1951.

Watson, John F. *Annals of Philadelphia and Pennsylvania*. Philadelphia: J.B. Lippincott & Co., 1870.

Wentz, Richard E., ed. *Pennsylvania Dutch: Folk Spirituality*. New York: Paulist Press, 1993.

Weygandt, Cornelius. *The Blue Hills*. New York: Henry Holt And Company, 1936.

White, Thomas. *Legends and Lore of Western Pennsylvania*. Charleston, SC: The History Press, 2009.

Yoder, Don. *Discovering American Folklife: Essays on Folk Culture and the Pennsylvania Dutch*. Mechanicsburg, PA: Stackpole Books, 2000.

Yoder, Don, and Thomas E. Graves. *Hex Signs: Pennsylvania Dutch Barn Symbols & Their Meaning, 2nd Edition*. Mechanicsburg, PA: Stackpole Books, 2000.

WEBSITES

"Archaeological Evidence of Witchcraft in PA?" http://twipa.blogspot.com/2011/10/archaeological-evidence-of-witchcraft.html. Accessed November 6, 2012.

Becker, Marshall J. "An American Witch Bottle." www.archaeology.org/online/features/halloween/witch_bottle.html. Accessed August 3, 2011.

Bentley, Tiffany. "Witchcraft in Williams Township, a history of the good and the evil." http://blog.lehighvalleylive.com. Accessed November 6, 2011.

"Crums Cemetery, outskirts of Windber, PA." www.pennsylvania-mountains-of-attractions.com. Accessed August 1, 2011.

Hoover, Stephanie. "Superstitious Dauphin County Residents Shun Witch." www.hauntinglypa.com. Accessed March 5, 2013.

Mullane, J.D. "The Burlington Witch Trial of 1730." www.phillyburbs. com. Accessed November 6, 2012.

"River Witch of Marietta, Pennsylvania." http://outtaway.blogspot. com/2010/10/river-witch-of-marietta-pennsylvania.html. Accessed February 2, 2013.

"Tour the Witch House, Maybe." www.roadsideamerica.com/news/16273. Accessed November 6, 2012.

"The Witch Trial at Mount Holly." www.museumofhoaxes.com/hoax/ archive/permalink/the_witch_trial_at_mount_holly. Accessed November 6, 2012.

Index

About the Author

Thomas White is the university archivist and curator of special collections in the Gumberg Library at Duquesne University. He is also an adjunct lecturer in Duquesne's history department and an adjunct professor of history at La Roche College. White received a master's degree in public history from Duquesne University. Besides the folklore and history of Pennsylvania, his areas of interest include public history and American cultural history. He is the author of seven books, including *Legends and Lore of Western Pennsylvania, Forgotten Tales of Pennsylvania, Ghosts of Southwestern Pennsylvania, Forgotten Tales of Pittsburgh, Forgotten Tales of Philadelphia* (co-authored with Edward White), *Gangs and Outlaws of Western Pennsylvania* (co-authored with Michael Hassett) and *A Higher Perspective: 100 Years of Business Education at Duquesne University.*

Courtesy of Justina White.

Visit us at
www.historypress.net

This title is also available as an e-book.